THE
ARMENIAN GOSPELS
OF
GLADZOR
THE LIFE OF CHRIST ILLUMINATED

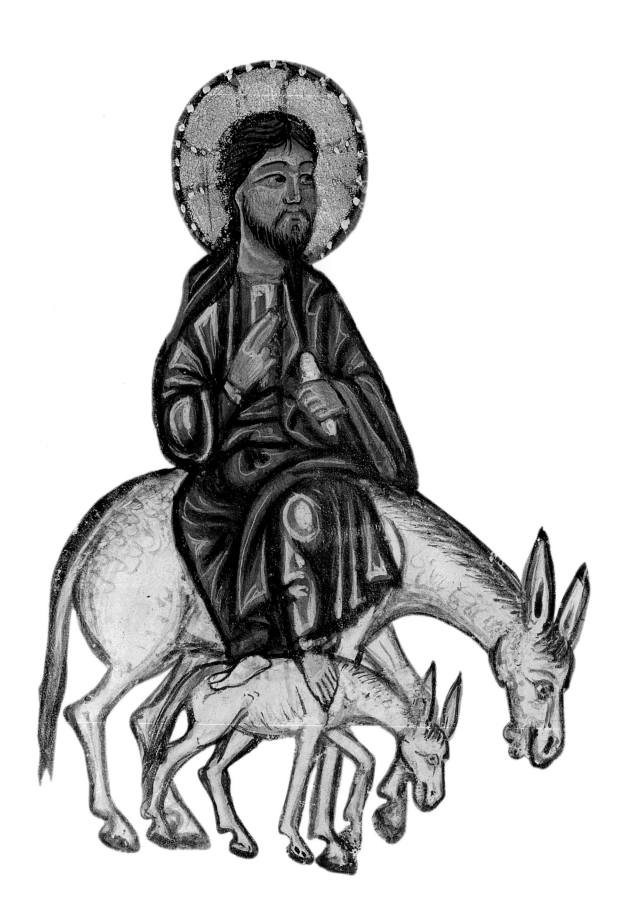

THE
ARMENIAN GOSPELS
OF
GLADZOR
THE LIFE OF CHRIST ILLUMINATED

Thomas F. Mathews and
Alice Taylor

The J. Paul Getty Museum *Los Angeles*

NOTE TO THE READER

Armenian is written in its own alphabet, which is beautifully suited to represent all the sounds of the language. There is no perfect way to write Armenian in Latin characters. The transliteration system used in this book is that of the Library of Congress, which seeks to produce words that, when read by an English speaker, approximate the sound of the Armenian.

Getty Publications
1200 Getty Center Drive
Suite 500
Los Angeles, California 90049-1682
www.getty.edu

Christopher Hudson, *Publisher*
Mark Greenberg, *Editor-in-Chief*

PROJECT STAFF
Michelle Ghaffari, *Editor*
Hillary Sunenshine, *Designer*
Elizabeth Zozom, *Production Coordinator*
Lou Meluso, *Photographer*

Professional Graphics Inc.,
Color Separator

Printed in Singapore by CS Graphics
PTD LTD

Library of Congress Cataloging-in-Publication Data

Mathews, Thomas F.
The Armenian Gospels of Gladzor : The life of Christ illuminated /
Thomas F. Mathews and Alice Taylor.
 p. cm.
Exhibition of UCLA's Armenian Gospel Book, known as the Gladzor
Gospels, presented at J. Paul Getty Museum.
Includes bibliographical references and index.
 ISBN 0-89236-626-5 (hardcover)
 ISBN 0-89236-627-3 (paperback)
 1. University of California, Los Angeles. Library. Manuscript.
Arm. ms. 1—Exhibitions. 2. Bible. N.T.
Gospels—Illustrations—Exhibitions. 3. Illumination of books
and manuscripts, Armenian—Exhibitions. 4. Illumination of books
and manuscripts, Medieval—Armenia—Exhibitions. 5. Illumination
of books and manuscripts—California—Los Angeles—Exhibitions.
I. Taylor, Alice. II. J. Paul Getty Museum. III. Title.
 ND3359.G46 M38 2001
 745.6'7491992—dc21

00-012617

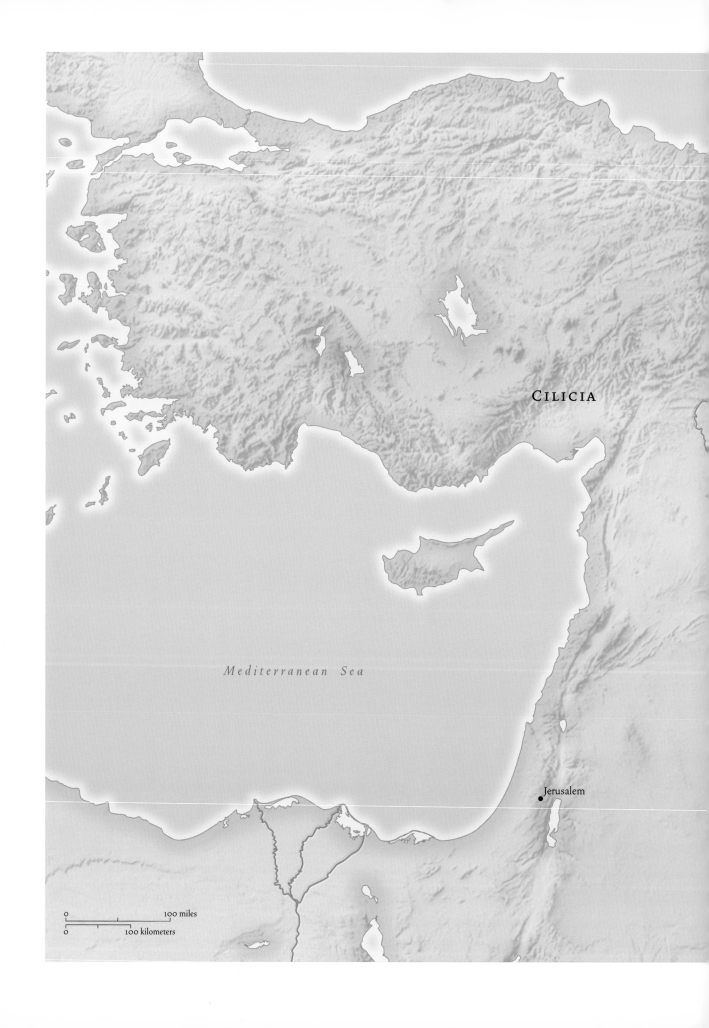

CILICIA

Mediterranean Sea

Jerusalem

0 100 miles
0 100 kilometers

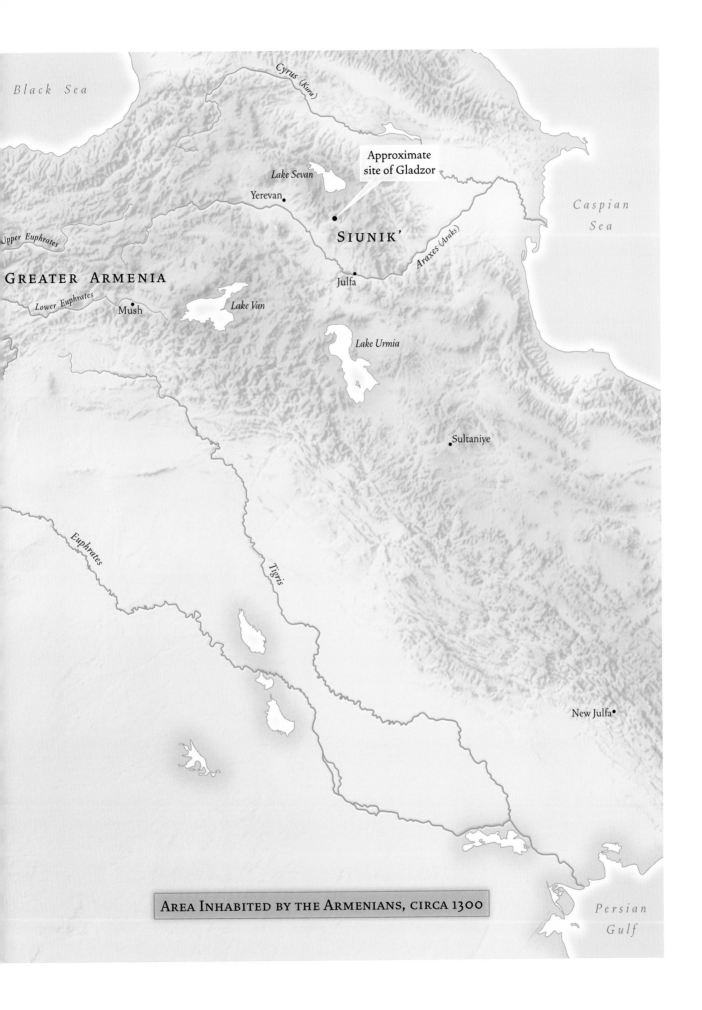

Black Sea

Cyrus (Kara)

Caspian Sea

Approximate site of Gladzor

Lake Sevan

Yerevan

SIUNIK'

Araxes (Araks)

Julfa

Upper Euphrates

GREATER ARMENIA

Lower Euphrates

Mush

Lake Van

Lake Urmia

Sultaniye

Euphrates

Tigris

New Julfa

AREA INHABITED BY THE ARMENIANS, CIRCA 1300

Persian Gulf

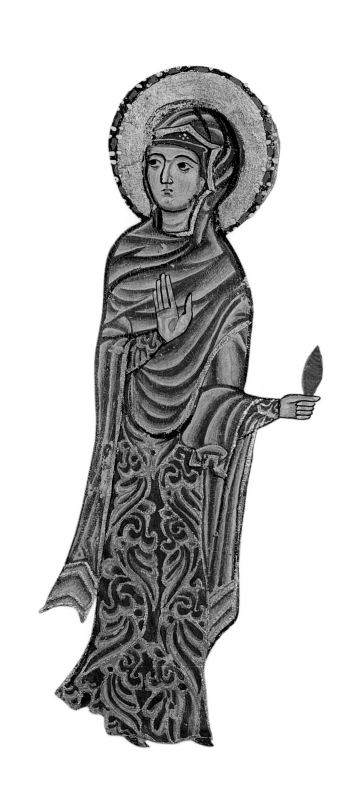

FOREWORD

Los Angeles has grown as a center for major art collections throughout the twentieth century, particularly in the last four decades. One of the areas consistently favored since the time of Henry Huntington is illuminated manuscripts. While the collections of the Huntington Library and the J. Paul Getty Museum are relatively well known, the collection of the Young Research Library at UCLA, which is strong in Armenian manuscripts, merits greater public attention.

The year 2001 marks the international celebration of the seventeen-hundredth anniversary of the establishment of the Armenian Church, the oldest national church in Christendom—the perfect occasion to draw attention to the importance of our neighbor's holdings. The exhibition that this volume accompanies, *The Armenian Gospels of Gladzor*, suggests the distinction of this body of manuscripts and its importance for our community. The exhibition features the Gladzor Gospels, a major achievement of Armenian illumination of the fourteenth century and one of the great Armenian manuscripts in America.

Since the book is disbound for the purposes of conservation, the exhibition offers a unique opportunity to examine its major illumination closely and to linger over the beauty and variety of its miniatures. To provide context, the installation includes a small selection of Armenian, Byzantine, and western European manuscripts from the Getty collection, as well as an Islamic candlestick from the University of Michigan Museum of Art. Thanks to the generosity of the Young Research Library at UCLA, a most gracious and willing partner, our visitors will come to better understand the place of the Armenian tradition of manuscript illumination and the quality of its representation in Los Angeles. We are particularly indebted to Gloria Werner, University Librarian at UCLA, and Anne Caiger, Manuscripts Librarian, Special Collections at UCLA, for generously facilitating the loan, the exhibition, and this publication. Susan Allen, former Head of Special Collections at UCLA, gave the initial encouragement for this project, and Ms. Caiger has supported the exhibition throughout the lengthy process of its germination. We also thank Thomas Kren, the Getty Museum's Curator of Manuscripts, and Alice Taylor of West Los Angeles College, who co-curated the exhibition. We thank James Steward, Director of the University of Michigan Museum of Art, for the generous loan of the medieval candlestick to the exhibition. Lastly, we gratefully acknowledge the contribution of Professor Thomas Mathews, John Langeloth Loeb Professor at the Institute of Fine Arts in New York, who co-authored this publication with Alice Taylor.

This is our second collaboration with UCLA's Department of Special Collections, the first being the popular *A Thousand Years of the Bible* held in 1991. We look forward to others in the future.

Detail of Plate 43.

Deborah Gribbon
Director

9

*T*he exhibition *The Armenian Gospels of Gladzor* takes as its subject a masterpiece of fourteenth-century Armenian manuscript illumination. This magnificent book was painted in two campaigns at separate monasteries in the Vayotz Dzor by teams of artists whose efforts were separated by some years. Its epic program of decoration offers a window onto Armenian religious belief and practice and a hearty taste of a rich pictorial tradition. Moreover, it brings to life an artistic center that has, quite literally, been buried by the sands of time. Although it was a lively intellectual center in the thirteenth and fourteenth centuries, the monastery of Gladzor, where T'oros of Taron and two collaborators completed the book's paintings, has disappeared.

The exhibition belongs to an ongoing series at the Getty that presents disbound illuminated manuscripts to the public, effectively turning the pages for the visitor to convey a sense of how the original owners may have used and enjoyed such books. Nearly fifty of the Gladzor Gospels' finest illuminations have been included. The show would not have been possible without the commitment of Anne Caiger and the generosity of the Young Research Library at UCLA.

The Gladzor Gospels has already been the subject of an important scholarly study, *Armenian Gospel Iconography: The Tradition of the Glajor Gospel*, by the late UCLA scholar Avedis K. Sanjian and art historian Thomas F. Mathews, John Langeloth Loeb Professor at the Institute of Fine Arts of New York University. For this publication, Professor Mathews has kindly agreed to revisit the topic and, in collaboration with exhibition organizer Dr. Alice Taylor of West Los Angeles College, offers further thoughts on the Gospels' illuminations and their meaning. We are grateful to him and to Dr. Taylor for their engaging and readable text. Professor Mathews would like to thank Annie-Christine Daskalakis for her reflections on the Mongolian context of the women in the manuscript. Dr. Taylor would particularly like to thank Florence and Alexandra Levitt for their support. Further, thanks to the superb color photography created by Lou Meluso in the Getty's Photographic Services Department, a substantial portion of the book's illumination is being reproduced in glorious color for the first time.

The exhibition was conceived by Dr. Taylor, who also organized the memorable *Book Arts of Isfahan*, held in our galleries in 1995. We are grateful to have once again enjoyed the benefit of her broad knowledge of Armenian manuscript illumination and culture in the Middle Ages. Elizabeth Teviotdale, Associate Curator of Manuscripts at the Getty, worked closely with the organizers and helped to guide this project from its early stages. Nancy Turner, Associate Conservator of Manuscripts, is responsible for the painstaking conservation treatment of the

Detail of Plate 42.

Gladzor Gospels, which has made possible both its exhibition and its closer study by present and future generations of scholars.

We would also like to thank Getty Publications for producing, as always, an exemplary publication. Michelle Ghaffari edited the book, Hillary Sunenshine provided the design, and Elizabeth Zozom was the production manager. Finally, two anonymous readers helped to improve an already superb and thoughtful text.

Thomas Kren
Curator of Manuscripts

CHAPTER ONE:
MAKING AN ILLUMINATED MANUSCRIPT

*I*lluminated manuscripts occupy a special place in Armenian culture. Apart from abundant architecture, manuscripts serve as the most important medium of artistic expression. They span over a millennium of Armenia's turbulent history, from the seventh to the eighteenth century, and they comprise a storehouse of national memory of singular importance.

Geographically wedged between the classical Greco-Roman and the Oriental (Iranian and Muslim) worlds, Armenia was at once the most ancient and the most eastern of all the kingdoms of medieval Christendom. Being a small nation situated between two great empires, Armenia charted its own course only when its powerful neighbors to the east and west were in near equilibrium so that neither dominated it. Generally, however, Armenia was subject to the rulers of other empires for longer periods than it was independent. Culturally, the country was pulled in both directions. Its social structure—a hereditary class system of great families under *nakharars*, or lords or magnates—allied it with Iran. Its Christianity, however, allied it with the Christian Byzantine Empire and the states of Europe. Thus caught in between, it nevertheless managed to maintain a surprisingly distinct identity. Armenia's conversion to Christianity under Gregory the Illuminator in 301 made it the earliest nation to embrace the Christian faith, which gave the country claim to some of the earliest Christian traditions. Responding directly to the needs of the new church, Mesrop Mashtotz developed an Armenian alphabet around 406 and began translating Sacred Scripture, and other Greek, Latin, and Syriac texts.

Armenia insisted on its own Christian traditions, even at the cost of a schism with Byzantine and Western Christians. One deep break occurred when other churches accepted the Council of Chalcedon in 451. In attempting to understand the most difficult of all Christian mysteries—how two natures (divine and human) coexist in the single person of Christ—the early Church Fathers had invoked the simple analogy of liquids poured together: the divine and human were thoroughly mingled, fused, and inseparable in Christ. Armenian theology always held firmly to this formulation. Things did not remain simple, however, and at the Council of Chalcedon, in response to assertions that the two natures actually became one nature after the Incarnation, the Greek and Roman Catholic Churches rejected the earlier metaphors of mixture and insisted that the natures remained distinct, that each nature was perfect and unconfused in Christ. The idea of mixed natures being incompatible with that of unconfused natures, the Armenian Church—along with several others—refused to accept the Council of Chalcedon. Thereafter, Chalcedonian churches often referred to the Armenians as Monophysites, while the Armenians viewed the Greeks (and later, the Roman Catholics) as Duophysites.

Detail of Plate 15.

To the modern world, the term *book* refers to the printed book, uniformly produced for a wide literate public. Before modern times, however, the public was largely illiterate. This meant reading was restricted to the ruling elite, to civil servants and businessmen who needed reading skills for their work, and to the clergy who had charge of the sacred deposit of learning found in Scripture. Everyone else experienced the book as something to look at and listen to rather than as something to read for themselves.

In the Middle Ages the book was a *manuscript* (something handwritten), which is a very different kind of object from the mass-produced printed books of today. The handwritten book was always a one-of-a-kind product. It was personally produced, usually to fill an individual commission. Someone decided he or she needed a book, found the craftspeople to make it, and raised the money to finance it, for its labor-intensive methods and more durable materials made it far more expensive than a modern printed book. First, the parchment had to be prepared from animal skins. Next, the scribe had to painstakingly copy each word of the text. The illuminators had to mix their own colors and apply the gilding by hand as part of their task of painting decoration and illustration in the book, after which a binder had to stitch the pages into its wood and leather covers. Thus an individual, personal element entered into every stage of a book's production. For this reason, no two manuscripts are identical.

The vast majority of medieval manuscripts were made for religious uses; therefore, text alone sufficed. For public reading in the services of the Church, or for private study by the devout, illustrations were not really necessary. The impulse to illustrate a text implies that the text was regarded as somehow inadequate for the purpose envisioned. It is clear that a book's sheer beauty could enhance its spiritual impact. The Muslim holy book, the Koran, never includes illustrations of people or animals. Rather, the quality of the materials used, the calligraphy, and the use of nonfigural illuminations make many Korans movingly beautiful.

Similarly, the Christian canon table decorations are nonnarrative. In Gospel books from all over the Christian world, these charts received elaborate illumination that had little relationship to their practical function. Their illuminaton could have spiritual value, as explained by the Armenian Saint Nerses Shnorhali (died 1173) in his *On the Canon Tables*:

> The compilers and followers of the Gospel illustrated it with luxurious herbs and multi-colored flowers and various inventions as a foretelling of earthly and heavenly things and a

service to the virtues, and through these [illuminations] the text before us also gives us to understand what the spiritual pleasures and imperishable beauties are.

There are many reasons to provide a book with narrative illuminations; for one, the addition of such pictures might clarify the meaning for an illiterate audience. In addition, lavish illumination might display the piety—or the power—of the owner. Probably the most important use of illustration, however, was to provide a visual commentary on the text. When William of Rubruck went on a diplomatic mission to the Mongol court in 1254, he carried illuminated manuscripts—a Bible, a psalter, and a breviary—to show to the Khan, who made special inquiry about the meaning of the miniatures. The precise use of the pictures in the Gladzor Gospels is not documented, but it is clear that what the patron was looking for was not just a text but a pictorial biography of Christ.

Such illustrations, then, should not be regarded as mere embellishment and display; rather, they are an essential part of the information system of the book. In many cases, the illustrations were more important than the text, for the scriptural texts were widely available and well established, having a sacred, unchanging status; often, the point of making a new illustrated manuscript was to offer a new interpretation of the text. In addition, it is not out of the question that the Gladzor Gospels served a didactic and propagandistic use, whether it served to explain the life of Christ to the monks or to the laity.

The life of Christ was very commonly illustrated, not just in the Gospel books (as was the norm in Armenia) but in manuscripts like psalters, which Byzantine and Western artists provided with illustrations to point out the application of the Old Testament text to Christ's life. Illustrations of Christ's life were always interesting precisely because the Gospels were open to numerous interpretations. A monk's interest in Christ's behavior would be very different from that of a noble lady, for example. The way in which Armenians read the Gospel story under Mongol rule in the fourteenth century was quite different from how they read it in the seventh century. Pictures placed alongside the text operate as a set of markers suggesting inferences to be drawn from the text. In this way the illustrations could make the text contemporary and personal without actually changing its words.

It is important to stress that the content of the image takes the reader well beyond the mere identification of characters and narratives of the text. The images develop a point of view, they tell the reader how characters are to be interpreted and what unexpected turns the plot may take.

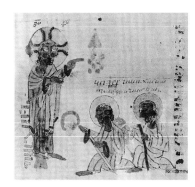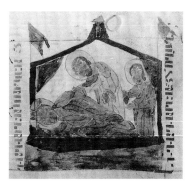

In the Gladzor Gospels Christ is not just the generic savior. On the one hand, the artist has something very particular to say about Christ's character when he shows Christ joyfully lifting a beaker full of wine (pl. 53), gently healing the blind (pl. 55), or courageously mounting the scaffold of his own execution (pl. 40). On the other hand, when the artist shows Salome and the gory end of John the Baptist (pl. 13), or Pilate receiving a secret plea for clemency from his wife while confronting the noisy crowd demanding Christ's life (pl. 26), the reader is asked to follow the important role of women in the subplots of the story. Some of these subjects are traditional, some are unusual; however, in either case, the same pictorial subject can carry a variety of messages, personal or popular, secular or clerical, political or pious, depending on how the story is developed. Read with a respect for these nuances, the illustrations of the Gladzor Gospels present a life of Christ faithful to the most ancient Armenian traditions.

To move with confidence among the meanings of the images, it is particularly useful to have other entrée into the world and the ideas of those who made them, and we are fortunate in being able to pinpoint two important persons involved in the making of the Gladzor Gospels. Within the image of the Second Storm at Sea (pl. 35), between Christ and the boat, the artist who was employed in the last phase of the book's illustration wrote an inscription to the abbot for whom the book was made. "O great master of mine, Yesayi [that is, Isaiah], remember this unworthy disciple of yours T'oros [that is, Theodore]." Yesayi, known as Yesayi of Nich, was a theologian and the abbot of the monastery of Gladzor, the most important Armenian monastery of the period. T'oros, known as T'oros of Taron, was the best known painter of the monastery, responsible for over one dozen additional surviving manuscripts. As a painter, however, T'oros evidently regarded himself as a special student of the great theologian, and thus there is an interesting relationship between the person commissioning the manuscript and the artist working on it. These two historical figures provide the key to a network of associations and links to both the intellectual and artistic life of the period.

Furthermore, we can identify a specific model used for the illustration of the Gladzor Gospels. Miniatures are seldom an entirely new invention, and their relationship to a tradition of illustrations is a complex affair. Unlike the copying of the text, which the scribe endeavors to reproduce letter-perfect, the composition of the illustrations is far from being a matter of routinely copying earlier manuscripts. When an artist chooses an earlier manuscript as a model, he or she generally has a special reason for regarding the model as venerable or authoritative. Not content with paying tribute to the older book, however, many artists engaged in creative

FIGURE 1
The Healing of the Blind Men at Jericho.
Vahap'ar Gospels; Lesser Armenia,
early eleventh century.
Yerevan, Matenadaran, Ms. 10780,
fol. 53 (detail).
After *Armenian Gospel Iconography:
The Tradition of the Glajor Gospel.*

FIGURE 2
The First Storm at Sea.
Vahap'ar Gospels; Lesser Armenia,
early eleventh century.
Yerevan, Matenadaran, Ms. 10780,
fol. 90 (detail).
After *Armenian Gospel Iconography:
The Tradition of the Glajor Gospel.*

16

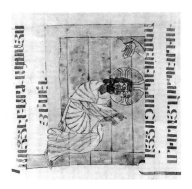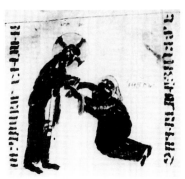

commentary on it by revising the pictures. The new illustrations, modern in their times, can be seen as a way of keeping current the ancient illustrations.

The Gladzor Gospels' model was the early eleventh-century Vehap'ar (Patriarch's) Gospels. Forty-two of the fifty-four subjects in the Gladzor Gospels, which is seventy-five percent, interrupt the text at exactly the same point at which they appear in the Vehap'ar Gospels. The treatment of the subjects in the Gladzor Gospels is sometimes almost exactly the same as that in the Vehap'ar Gospels (pls. 20, 32; figs. 1–2), while at other times they further develop the earlier image (pls. 23, 55; figs. 3–4). Clearly, the designer of the Gladzor Gospels took the Vehap'ar Gospels as his model, enriching it with several images that were in more general circulation. The choice of this manuscript as program model implies that a special authority was attributed to the Vehap'ar Gospels. It is possible that the threats to Armenian traditions posed by Mongol occupation and Roman Catholic missionaries in Armenia gave the Vehap'ar Gospels a special validity.

At the same time, the artists of the Gladzor Gospels looked to a more recent Armenian tradition in the manuscripts of Cilicia. From this source come the illuminated initials in the text, and the marginal pericope markings enlivened with birds and foliage. The finest Cilician Gospels also framed the Gospel texts with illuminated canon tables and evangelist portraits facing elaborate incipit pages. In the Gladzor Gospels a splendid set of canon tables and evangelist portraits facing illuminated incipit pages form a decorative introduction and frame for the life of Christ in the narrative miniatures; however, it is the narrative miniatures that constitute the principal subject of this study.

It is clear from its structure that the Gladzor Gospels was made in two separate campaigns: first, the text was copied and spaces were left for paintings, and two artists, each with a distinctive style, began the paintings. At some point the work was interrupted, and in another campaign a set of painters, working in yet another style, completed it. Among the second set was T'oros of Taron. Both sets used the Vehap'ar Gospels as a model. No colophon tells us where or when all this happened. Having identified T'oros of Taron and Yesayi of Nich in the inscription in *The Second Storm at Sea*, we can place the Gladzor Gospels at Gladzor, at the beginning of T'oros's career prior to 1307. A colophon added to the Gospels in 1377 recalls that the Gospel book was made at Gladzor. T'oros seems to have been the last of a series of artists who worked on the manuscript, even reworking paintings. In the Annunciation, for example, the Virgin's face painted by T'oros contrasts with the rest of the work, completed by the painter of the evangelist portraits (pl. 43).

FIGURE 3
The Agony in the Garden.
Vahap'ar Gospels; Lesser Armenia, early eleventh century.
Yerevan, Matenadaran, Ms. 10780, fol. 70 (detail).
After *Armenian Gospel Iconography: The Tradition of the Glajor Gospel.*

FIGURE 4
The Healing of the Man Born Blind.
Vahap'ar Gospels; Lesser Armenia, early eleventh century.
Yerevan, Matenadaran, Ms. 10780, fol. 236 (detail).
After *Armenian Gospel Iconography: The Tradition of the Glajor Gospel.*

Two painters worked on the first stage of the Gladzor Gospels' creation. The canon tables were illuminated in a meticulously detailed style that also appears in most of the marginalia and initials. That the Canon Table Painter worked alongside the Evangelist Painter is strongly suggested by the fact that the latter painted initials on almost fifty pages toward the end of the manuscript, after which the Canon Table Painter finished the remaining initials. The canon table pages, in the tradition of Armenian Cilicia, are delicately detailed compositions: here are leaves, flower buds, and birds (pl. 6) quite similar to those that make up most of the initials (pl. 17). The Evangelist Painter produced a clever variation on these forms, for what at first glance seem to be leaves and buds in his marginalia are actually tiny animals and birds (pl. 56; see detail on p. 30). He used the same witty technique in the illumination of the first pages of Mark and Luke: on the incipit page to Mark (pl. 30), fanciful animals contort themselves into the marginal decorative element; on Luke's there is a "running" border formed of quadrupeds, buds of human faces, and leaves of paired birds (pl. 42; see detail on p. 119).

It is not likely that the Evangelist Painter and the Canon Table Painter worked at Gladzor. Their highly controlled work contrasts sharply with the painting in the rest of the manuscript, in which paint is layered in rough, free strokes. The difference in approach seems to indicate two workshops; chemical analysis of the pigments confirms this by establishing that the rougher-style paintings employ a purple and a yellow not found in the smoother ones. Surely a single monastery would not support two distinct traditions in the preparation of paints or such a wide range of painting styles. It is unlikely, therefore, that the Canon Table Painter and the Evangelist Painter worked at Gladzor, where the manuscript was completed.

Indeed, the Canon Table Painter's work is completely within the tradition of Cilicia, while the Evangelist Painter fits securely with the style of two painters active in Siunik': Momik and Sargis. Sargis is known from one manuscript, a Gospel book he illuminated at the monastery of Yeghegis in 1306 (fig. 5). Momik's illumination is found in two manuscripts he painted at Noravank' in 1292 and 1302 (fig. 6). Sargis's and Momik's work shares a markedly linear style that stresses contour with an unsigned manuscript made at Noravank' in 1300 (fig. 7), and which has its most inspired example in the work of the Evangelist Painter in the Gladzor Gospels. It seems reasonable, then, to assign his work to a center such as Noravank' or Yeghegis. These two monasteries are only a few kilometers apart, and, like Gladzor, they are located in the Vayotz Dzor (the monasteries will be discussed in more detail in the next chapter).

The Canon Table Painter's work is limited to the canon tables and initials, while the

FIGURE 5
Sargis, *The Raising of Lazarus*
(with fragments of portraits of
Saint John and Carpianos).
Gospel book; Yeghegis, 1306.
Yerevan, Matenadaran,
Ms. 10525, fol. 138.
After *Armenian Gospel Iconography:
The Tradition of the Glajor Gospel.*

FIGURE 6
Momik, *The Transfiguration*.
New Testament; Noravank', 1302.
Yerevan, Matenadaran,
Ms. 6792, fol. 5v.
After *Armenian Gospel Iconography:
The Tradition of the Glajor Gospel.*

OPPOSITE (above): FIGURE 7
Incipit Page.
Gospel book; Noravank', 1300.
New Julfa, All Savior's Church,
Ms. 477, fol. 249.

OPPOSITE (below):
Detail of Plate 5.

Evangelist Painter executed many narrative illustrations, scattered throughout the book. One gets the impression that he was interrupted as he went about filling in all the spaces.

The book was finished by a group of painters including T'oros of Taron, who, as we have seen, was the only painter to sign his work in the Gladzor Gospels. A close look at the way faces were painted makes it clear that three different artists worked on the manuscript at Gladzor. T'oros began his faces with a layer of creamy yellow paint, on which he modeled the features with strokes of green and white (see, for example, the face of the Virgin Mary on p. 8). We refer to another, anonymous painter as the Painter of the Olive Ground because he began his faces with a layer of drab olive paint over which he layered a white and milky pink paint (see the detail of pl. 21 on p. 2). A third painter of the Gladzor group is the Painter of the Green Ground, who so fully covered the green ground layer in his faces with brown, white, and red that it is visible only as shadows. T'oros reworked some of these faces, as well as the work of the Evangelist Painter, suggesting that he may have been the last painter to work on the manuscript.

CHAPTER TWO:
ARMENIA UNDER THE MONGOLS

*T*he Gladzor Gospels is a product of a fascinatingly complex chapter in Armenian history, when Armenians lived under the rule of Mongols and Georgians, as well as under the rule of the Armenian kings of Cilicia. This was a world in which political, economic, ethnic, and religious boundaries were constantly being reworked. The terms in which Armenians understood such boundaries were debated and defined in monasteries, including the ones where the Gladzor Gospels was made. Like Christian monasteries throughout the medieval world, the Armenian monastery was meant to be a place of refuge from the secular world, a place where the life of the spirit would take precedence over the affairs of the secular world outside. However, where thirteenth-century Byzantine or French monasteries were enclaves of the spiritual within a larger, fairly homogenous Christian society, Armenian monasteries found their niches in a far more complex cultural landscape.

The area historically inhabited by Armenians extended well beyond the boundaries of the current Armenian Republic. Aside from sizeable enclaves of Armenians living in distant lands—for example, in Jerusalem or Byzantine Thrace—Armenians lived in a swath of territory extending from the Mediterranean coast at Cilicia northeast to Georgia in the Caucasus. In the thirteenth century parts of this world were ruled by the Armenian king of Cilicia, by various Seljuk groups, and by the royal house of Georgia. The Seljuks, tenth-century arrivals from Central Asia, were Muslims and spoke a Turkic language. Although both Georgians and Armenians were Christians, each considered the other's church to be heretical. There were still other Christians in the area: the Syriac-speaking Christians and the Nestorians of Persia. Cilician Armenia was allied with the Greek Orthodox Byzantine Empire, then with Roman Catholic Crusaders. Only the Georgians and the Byzantines wholly accepted the teachings of any of the others.

One way that Armenians managed to retain their identity as Armenians in such a setting was that their institutions preserved their community while allowing it to interact with outside powers. One particularly flexible institution was the *nakharar* system. Although it is much older, the *nakharar* system resembles Western feudalism. Much like feudal nobility, the *nakharars* enjoyed hereditary rights to their lands, and their support formed the basis of royal power, just as their ambitions could splinter it. Ideally, the *nakharar* had a distinguished lineage—in many cases traced back to Noah—and served an Armenian king. In fact, most *nakharars* had more recently become a part of the noble class, generally through military service. When Armenians lived under other peoples with similar ideas of service based on mutual loyalty, the *nakharars* could direct their fealty to non-Armenian kings. This proved particularly useful to

Detail of Plate 17.

Armenians living under Georgian (and later Mongol) rule. The Armenian brothers Ivane and Zak'are served the Georgian Queen T'amar (reigned 1184–1213). Rising to the heights of the Georgian army and court, they achieved for themselves the status of a *nakharar* family, called the Zak'arians, in honor of Zak'are. Queen T'amar gave the Zak'arians control of almost all her Armenian territories, including the former Armenian capital Ani. The Zak'arians established their own vassals, comprising both surviving *nakharars* and new men—from among their own Armenian generals—raised to *nakharar* status, each with smaller territories as their own fiefs. Among the new *nakharars* was the Proshian clan, who were particularly important for the history of the Gladzor Gospels.

At least since their adoption of Christianity, Armenians have identified themselves as a distinct people, separated from their neighbors by language and religion. In the eighth century, following a series of invasions by the Arabs, Armenian art and literature began to exhibit a longing for the Armenian kingdom as it was imagined to have existed at the beginnings of Christianity. For many contemporaries, the Zak'arian clan was a revival of Armenian glory lost in the Seljuk invasions.

In addition to renovating the great trading city of Ani, the Zak'arians and their vassals took up the habits of earlier Armenian nobility. Particularly significant were the restoration of neglected monasteries and the foundation of new monasteries. Donation inscriptions on monastic buildings set out the terms of the mutual support between *nakharar* lords and monks. The lords paid for the construction of new churches and other buildings, and donated villages and land to support the monks materially. The monks undertook to pray for the nobles and to care for their graves. Modern historians have noted that the economic and political benefits monasteries provided to the lords extended beyond these spiritual services. Monasteries were extensions of family power, holding land, providing accommodations, and presenting the image of the *nakharar* to his people. *Nakharar* families and their monasteries were united, in both a spiritual and financial sense. It would be anachronistic to ignore the basic desires expressed in the donation inscriptions. The business of these monasteries was salvation: the salvation of the monks, of the lords, and of the Armenians in general.

Saving the Armenians was a delicate task. Throughout the thirteenth century, Armenians faced difficult questions as to what it meant to be Armenian. The clear-cut qualification was to be a Christian who spoke Armenian. During this period there are no traces of argument as to what the Armenian language was; however, the question of what constituted a Christian loomed large. In the case of Ivane and Zak'are Zak'arian, thirteenth-century Armenian historians note

that the family ancestors were Christianized Kurds, but neither their non-Armenian heritage nor their allegiance to a foreign queen detracted from the glory of the Zak'arian *nakharar* clan. What disturbed the historians was Ivane's Christianity. One historian, Vardan Aravelts'i, wrote, "Ivane, deceived by Queen T'amar, weakened in the faith. However, Zak'are, Ivane's brother, remained in his own faith." For a twenty-first-century observer, the difference between Georgian and Armenian Christianity may seem insignificant, centering as it did on just how the divine and the human natures are understood to be united in Christ. Over time, the separation of the churches grew to encompass further differences, including matters of ritual and calendar; however, the understanding of Christ remained the critical issue separating the Armenian Church from that of its powerful neighbors, the Georgians and Byzantines, and thus helped define the Armenian people.

Ivane Zak'arian came to terms with Queen T'amar and her form of Christianity, and Vardan Aravelts'i did not approve. Similar understandings were reached by the Armenian kings of Cilicia: their allies were the Roman Catholic Crusaders, and from time to time the Cilicians saw fit to adopt Latin customs, ranging from the use of feudal vocabulary and Western dress, to the recognition of the Council of Chalcedon and its un-Armenian definition of the two natures in Christ. Desperate for a Christian ally in the face of the Mamluk invasion, King Het'um II (reigned 1289–1297), ruler of the Cilician kingdom of Armenia, adopted Roman Catholicism on behalf of his people. The papal alliance was not popular, but Het'um's successors convened synods in 1307 and 1317 to implement the union, and the Pope sent Catholic missionaries—Franciscans and later Dominicans—to carry out the Latinizing of the church on the local level. Thus Vardan Aravelts'i had to deal with the paradox that what were to him clearly Armenian kings sometimes did not seem to adhere to the Armenian faith.

By the time of Het'um's conversion, the arrival of yet another non-Armenian people, the Mongols, had presented an even greater intellectual challenge for thirteenth-century Armenian historians. Mongol conquests created the world's largest empire, including most of Asia and significant parts of Europe (for example, China, Korea, Central Asia, Austria, Hungary, Russia, Persia, Georgia, and Armenia). The Mongol conquest of Armenia involved a staggering loss of life and property from the time the Mongols first arrived in 1220 until 1236, when the Georgian king and his Armenian vassals, including the Zak'arians, submitted to Mongol rule and became, in effect, vassals of the Great Khan.

It is easy to place the Mongol conquest in the long sequence of invasions that had disastrous

results for Armenia. The Mongols were herdsmen, and their need for pasturage led to the decline of agriculture and related civic life. Their destruction of Ani was a blow to Armenian trade. Armenians were required to provide numerous troops for the Mongol armies as they continued their westward advance. All of these occurrences resulted in massive emigration, particularly to the Crimea.

Much of Armenian life went on as before, however, especially where Armenian *nakharars* ruled as Mongol vassals. The role of the monasteries actually increased. The Mongols who arrived in the Transcaucasus had not yet adopted Islam as their religion (this took place sometime between 1296 and 1304). They exempted religious establishments from taxation, so that by giving generous endowments to the monasteries, the nobility could keep control of their family lands—similar to the way in which a modern family transfers funds to a tax-free charitable family foundation. As the Mongols allied with the Cilician Armenian kingdom, a sense that good Armenians were loyal to the Mongol Khan seems to have taken root. Thus, writing of an Armenian warrior prince, Vardan says, "Sevada Khachentsi was killed fighting valiantly. He was crowned with those who keep the faith and fear of God and of the Il-Khan; to him may a share [in Heaven] be granted by the blood of the martyrs of Christ, those who keep his faith and fear. Amen." The same author who condemned Ivane for deserting the true faith recognized the Nestorian wife of the Khan Hulagu as a Christian, generously attributing her differences with the Armenian faith to simple, innocent ignorance.

A degree of tolerance was required in order to benefit from Mongol rule. Not only were Nestorian Christians prominent at the Mongol courts but other Christians—many of them on diplomatic missions—gathered there as well. Both the Cilician Armenian King Het'um I and his brother, Constable Smbat, went to court seeking allies against the Mamluks; Bishop Smbat Orbelian went to protect his family lands in Siunik'. William of Rubruck visited on behalf of Louis IX, and began what would be a long series of efforts to convert the Mongols to Roman Catholicism. In the complex world of the thirteenth century, Armenians had to reconsider their faith and its forms, and from Cilicia to Georgia, accommodations were made.

Since none of these compromises was simple or uncontested, the intellectual work of explaining who was to be accepted as a fellow Christian had a particular urgency. The great flourishing of Armenian culture in the Crusader and Mongol periods may be seen to revolve around just such issues of religious identity. Although some of the alliances were expedient, it is highly reductionist to interpret the accompanying religious debates as posturing. The

discourse on Armenian Christian identity, which had a real impact on the secular world but was still religious in content, was primarily the concern of the church. The great surviving Armenian histories of the thirteenth century are by monks—Grigor Akants, Vardan Aravelts'i, Krikor of Gandzak—and Step'anos Orbelian, a bishop. Each explains from his own point of view how various alliances came about and (not surprisingly) how those of their own *nakharar* houses were appropriate, while those of other houses frequently were not. Similar issues are explored in other genres: it is in the contested grounds of Cilicia in the twelfth century and greater Armenia in the thirteenth century that we find a sudden flowering of law books, collections of fables, homiliaries, menologia, and collections of hymns, all of which were aids to defining the ways of a good Christian and Armenian. Of course, there is also an extensive literature focusing more directly on the theological issues that distinguished Armenian Christians.

Almost without exception, this writing was done in monasteries, the centers of medieval Armenian writing and book production. Many of the authors were also scribes, and the work of preparing parchment and ink, illuminating books, and binding them was shared by various members of the monastic community. Autograph copies, made for a particular reader and sometimes employing the help of that reader, are not uncommon among thirteenth-century Armenian books. Similarly, the kind of relationships implied in such a book—copied out by the author for a pupil who helped in the work—can be seen in other areas of monastic life. The Armenian honorific title of *vardapet* had long been used to indicate a religious teacher of the highest qualifications. In one of the compilations of laws that we have suggested was part of a large-scale response to the challenges of defining the Armenian faith in the twelfth and thirteenth centuries, Mkhitar Gosh codified the process of conferring this rank: at least two *vardapets* had to agree that a candidate was worthy to be called a *vardapet*. In this process, as in many others, chains of pupil-teacher relationships extended far beyond any single monastery. Many of these can be traced in colophons. For example, in the mountain-bound province of Siunik' at Gladzor, we meet the *vardapet* Nerses, a native of Mush in the western province of Taron. Nerses had taught in the province of K'achberunik' on the east-west trade routes at Lake Van, then studied with Vardan Aravelts'i at Khor Virap, before finally coming to Gladzor. With him came his student, Yesayi from Nich, south of Taron. Students came to Gladzor from as far west as Cilicia and from Vorotn, farther east in Siunik'. Although the monasteries might be separated by distance (see map on page 26), patronized by rival *nakharars*, and even in heartfelt disagreement about the nature of Christ, intellectual connections persisted.

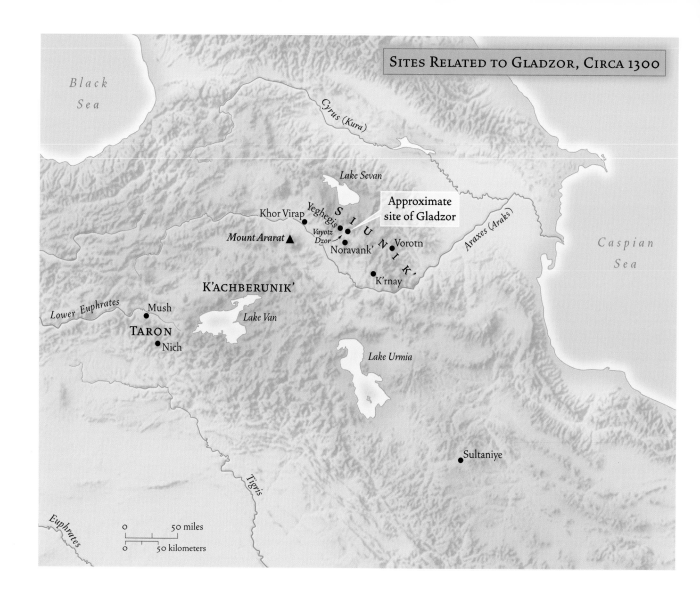

Black
Sea

Cyrus (Kura)

Lake Sevan

Approximate
site of Gladzor

Khor Virap Yeghegis
S I U N I K'
Mount Ararat ▲ Vayotz
Dzor
Noravank' Vorotn

Araxes (Araks)

Caspian
Sea

K'rnay

K'ACHBERUNIK'

Lower Euphrates Mush
TARON Lake Van
Nich

Lake Urmia

Sultaniye

Tigris

Euphrates

0 50 miles
0 50 kilometers

As seen in the previous chapter, the Gladzor Gospels also connects two separate monasteries in Siunik': the one in which the book was begun (most likely Noravank' or Yeghegis) and the one where it was completed (Gladzor). Information about these connections comes not just from texts but from images as well.

Noravank' was the principal monastery of the Orbelian *nakharar* family, while Yeghegis was a smaller one. When the Orbelians served under the Mongols, Siunik' was a refuge where Armenian culture flourished. Step'anos Orbelian's *History of the Province of Sisakan* (also known as Siunik') stresses the glorious role of his family in preserving the province, in particular, the Armenian Church located there. The artists most closely associated with the Evangelist Painter (see p. 18) also served the Orbelians. In addition to illuminating a manuscript for Step'anos Orbelian in 1302, Momik carved a stele for Step'anos's grave around 1304. In 1307 he began copying a Gospel book for Ivane Orbelian, metropolitan of Siunik', and in 1308 he sculpted another stele, this time for Prince Tarsayich Orbelian. Momik supervised the building of a church near Noravank' for Ivane in 1321, and executed its sculpture. In 1331 he returned to the Gospel book he had begun in 1307 to record that the book now belonged to Ivane's successor, another Tarsayich Orbelian. Momik died in 1333 and was buried at Noravank'. Yeghegis appears to be a related center: in addition to Sargis's work there in 1306, Momik wrote his colophon of 1331 in Yeghegis.

Much of the manuscript illumination of Siunik' refers to older models. Sargis, Momik, and an anonymous artist working at Noravank' in 1300 (also closely associated with the Evangelist Painter) all copied the illuminations of an eleventh-century Gospel book. As we have seen, this is also true of the Gladzor Gospels, which follows the Vehap'ar Gospels, another eleventh-century manuscript. This grounding of new work in the past recalls Step'anos Orbelian's attempt to link his family with the beginnings of Armenian Christianity. A strong attachment to the Orbelian family, to the Armenian past, and to the Armenian Church, seems to inform this literary and artistic production.

Much the same can be said of Gladzor, where the Gladzor Gospels was completed, if one simply substitutes a rival *nakharar* family—the Proshians—for the Orbelians. There is much more information available about the activities of Gladzor than there is about Yeghegis, however, or even Noravank'.

The precise location of Gladzor is not known; although the monastery, and consequently its buildings' inscriptions, does not survive, textual sources give a reasonably clear picture

of its activities. In the 1260s the historian Vardan Aravelts'i refers to its school as already flourishing. Two successive *vardapets* determined the intellectual character of the school. The first was Nerses of Mush who, between his arrival in 1280 and his death in 1284, attracted a strong following of students from as far away as Cilicia and Lake Van. The second was one of his students, *vardapet* Yesayi of Nich, who remained as abbot over a half century until his death in 1338.

Some scholars have argued that the trivium and quadrivium of Western medieval universities also shaped the curriculum of Gladzor, but there is little evidence of this in the sources. The school of Gladzor had its own structure with a division of courses and grades of accomplishment leading to admission to the rank of *vardapet*. The main curriculum was called "internal and external commentaries and translations," a terminology also found in Byzantium. "Internal" referred to the knowledge of God attainable only through God's revelation as found in the study of Scripture and the works of the Fathers of the Church who commented on Scripture; "external" referred to the ancient, pre-Christian authors, whose treatises on philosophy supplied the categories and terminology used in Christian theological discussion. Beyond these substantial subjects taught at Gladzor, the more practical skills of music and painting are also mentioned; however, the reference is to church music and the painting of manuscripts rather than to art in a broader sense.

The best evidence for the scope of the studies pursued at Gladzor is the survival of a body of sixty-nine manuscripts produced at the monastery (now dispersed in various libraries). The list includes Plato's *Timaeus*, Aristotle's works on logic (in Armenian), and commentaries on Aristotle's logic by the seventh-century Armenian philosopher David the Invincible; however, the bulk of the manuscripts are biblical. Sixteen Gospel books and six Bibles make Scripture itself the largest category, accounting for one-third of the manuscripts. The remaining books are chiefly works of theology and most of the theological works are exegetical, that is, commentary on Scripture. It is more remarkable that among the surviving manuscripts one can find commentaries on virtually every book of the Old and New Testaments. In other words, exegesis was pursued with a system and a thoroughness that made it the main focus for the curriculum of the school. The abbot Nerses of Mush wrote commentaries on Daniel, Proverbs, and the Song of Solomon, while Yesayi wrote verse-by-verse commentaries on Ezekiel and Isaiah. The single surviving portrait of Yesayi shows the master engaged in explaining Scripture (fig. 8). Heavenly inspiration flows into his ear and out of his mouth to the encircling brethren. A monk

OPPOSITE (above): FIGURE 8
Yesayi Teaching.
Commentary on Isaiah by
George of Skevra; 1301.
Jerusalem, Church of Saint James,
Ms. 365, p. 2.

OPPOSITE (below):
Detail of Plate 5.

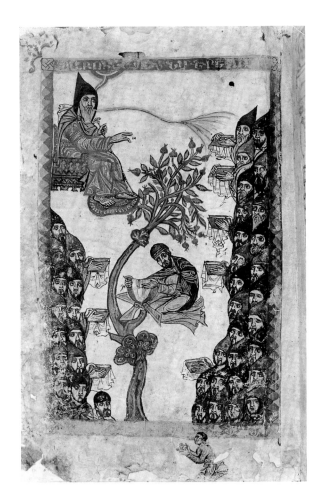

in the middle holds a Bible on a reading stand, while many of the other monks hold their own Bibles or commentaries cradled in a cloth of honor. This is interesting evidence of wide dissemination of books in the monastery.

The colophons of the sixty-nine manuscripts show that the production of manuscripts at Gladzor was largely for internal consumption. Only five manuscripts can be securely identified as made for outsiders, and only one for a layperson—a Gospel book for the princess Vakhakh Orbelian. In other words, manuscript production at Gladzor was generally a matter of monks making books for their own use or for the use of their brethren. These monastic painters, therefore, worked for a highly literate circle of men who were engaged in serious research on Scripture.

Gladzor is an example of the many monasteries that played a key role in Armenian intellectual tradition. Monks at Gladzor, and especially its great *vardapet*, Yesayi of Nich, were countering Roman Catholic teachings that had first taken on importance in Cilicia. Step'anos Orbelian's letter to the Catholicos in Cilicia spelling out the opposition to a rumored union with Rome, includes the defiant position, "We are willing to go to hell with our forefathers rather than ascend to heaven with the Romans." According to Step'anos, Yesayi of Nich signed this letter on behalf of himself and his students at Gladzor. It is in accord with Yesayi's work at Gladzor, which focused on analyzing, explaining, and above all, preserving the teachings of the Armenian Church.

CHAPTER THREE:
THE LIFE OF CHRIST IN MINIATURE

*T*he translation of the Gospels into Armenian in the fifth century introduced no
significant variants from the original Greek text; the sermons and miracles remained identical.
To compose a specifically Armenian life of Christ was the work of exegetes and illuminators who
embroidered their commentary onto the common fabric of the Gospels. The Gladzor manu-
script is a most eloquent and very self-consciously formulated version of the Armenian life of
Christ, and it deserves to be appreciated for its peculiarly Armenian content.

The images at each stage of the Gladzor Gospels give the story a twist. At times the pictorial
commentary refers to doctrinal matters important to Armenians, to social issues, or to Arme-
nian customs in ritual and hierarchy. At other times the treatment of the subject is simply archaic;
but in view of Armenia's historic place as the earliest Christian nation, being Armenian involved
being archaic. Ecclesiastical conservatism in Armenia preserved many traditions that Chris-
tians elsewhere had forgotten or put aside. In each case, however, the reading of the life of
Christ is significantly different from that of the Greek and Latin churches.

To understand how the artists have turned the life of Christ to suit their special purposes,
one must simultaneously follow two lines of inquiry. It is necessary first to examine how the
miniatures stand apart pictorially from the usual iconographic tradition for a given subject. For
example, in the Gladzor Gospels the narrative begins with the most extensive set of illustra-
tions of the Ancestors of Christ ever attempted in medieval manuscripts (pls. 9–12). This bold
set of figures gives a special Armenian direction in reading the bare, dry list that Matthew gives
of Christ's forebears. At the same time, to explain the pictorial idiosyncrasies a second line of
inquiry must consider the written sources from Armenia that comment on the life of Christ. In
the case of the Ancestors, for example, sources reveal that lineage had a special meaning in a na-
tion whose society was structured by a hereditary class system.

In attempting such a reading of the pictorial language of the Gladzor Gospels, one has the
special advantage of a contemporary commentator at Gladzor. Scribal signatures show that
both the last artist T'oros and his abbot, Yesayi, worked on manuscripts together with another
monk, John of Yerzinka (surnamed Tsortsorets'i), whose *Commentary on the Gospel According
to Saint Matthew*, fortunately, has survived. Since most of the stories in Mark and Luke are also
in Matthew, this commentary is extremely useful, and often gives us a way of tying the particu-
lar imagery of the miniatures to theological speculation current in the monastery at that very
moment. Beyond John of Yerzinka, one can turn to earlier literary sources that enjoyed wide
circulation in Armenia: the commentaries of Saints John Chrysostom and Ephrem the Syrian,

Detail of Plate 56.

the Armenian catechism known as the *Teaching of Saint Gregory the Illuminator*, and a variety of hymns and prayers in the Armenian divine services. These texts provide an opportunity to witness the distinctly Armenian way of construing the life of Christ.

The fifty-four narrative paintings in the Gladzor Gospels present a very complete life of Christ from the Annunciation until his disappearance into Heaven. With such a wealth of narrative detail it is difficult to reduce the resulting portrait of Christ to a few simple lines. There are, however, certain strong traits that persist with great regularity throughout the whole set; we have therefore divided our inquiry according to large themes. This seems to make more sense than conducting either a chronological or a page-by-page study. There is a certain amount of overlapping in the categories, since a given miniature may illustrate more than one aspect of Christ's person or his relationships with the world. It is hoped, however, that this approach respects the shape of the narrative as told by the painters of the Gladzor Gospels.

The Divine Physician

Christ's miraculous cures are a strong theme used in defining his person. Nine miniatures, or one-sixth of the whole Gladzor Gospels set, deal with this theme, giving a special weight to this aspect of Christ's character. This should not be taken for granted; in the West, for example, the cures were widely neglected. In the famous Arena Chapel at Padua (circa 1305), Giotto tells the story of the life of Christ in thirty-eight panels, but only one of these—*The Raising of Lazarus*—is a miraculous cure. Like many other artists, Giotto preferred the tender moments of the infancy of Christ and the heartrending events of his Passion. The Gladzor Gospels' interest in Christ the Physician is one of the more archaic aspects of its portrait of the savior, which survived in Armenia long after other Christians had lost sight of it. The art of the early church—for example, the sarcophagi and the cemetery frescoes of Rome—showed a similar preoccupation with the cures, and in early Syrian theology, on which Armenian authors drew heavily, Christ the Physician is a major theme. This Christ is a very personal, caring savior: he is directly involved with other people, sensitive to their problems, and in touch with them even on a physical level.

Four cures of the blind are illustrated, with varying emphases. *The Healing of the Blind Men at Jericho* places the two unfortunate beggars on the right against a background of city walls representing Jericho (pl. 20). Christ and his two disciples, coming from Jerusalem, stand somewhat removed on the left, set off by a glittering gold background. While earlier commentators emphasize

the virtues of the blind men—the persistence and humility of their prayer—the Gladzor commentator John of Yerzinka makes a broad, all-inclusive allegory of the whole event. Jericho and Jerusalem are opposed as Earth and Heaven, and "Bartimaeus," the name of one of the blind, is taken to mean "Son of a Blind Man," implying that all of Adam's children are blind sons of blind fathers. The gates of Jericho are the portals of death. Passing through them, Christ illuminated both Gentile and Jew; that is, the two blind men. In other words, the reader is being introduced to a Christ who stands astride all human history, working the cure of all humanity.

While this cure is effected from a distance, two other cures of the blind are shown as involving physical contact with Christ. *The Healing of the Blind Man at Bethsaida* (pl. 36) and *The Healing of the Man Born Blind* (pl. 55) both involve Christ's application of clay to the eyes of the blind. In the latter one sees a very elegant figure of Christ, head and shoulders taller than his disciples, bending gently over the blind man. By this gesture Christ was thought to reveal his identity as the Creator who had used clay to make man in the beginning, as described in Genesis 2:7. Opening their eyes, the men beheld not just Mary's son but the Creator of light who had now returned to enlighten humankind. This kind of reasoning, then, is characteristic of Armenian exegesis and lies behind the Gladzor life of the savior. Christ spans the whole of history, so that his every deed encapsulates all of God's work in creating and saving humanity. The Armenian Church inherited this comprehensive approach to interpreting an event from early Syria, where it was especially popular.

Other representations of the miraculous cures show a Christ who is even more intimately involved in humanity's woes, as in *The Healing of the Leper* (pl. 31). When this incident is represented elsewhere in medieval art, artists circumspectly avoid showing Christ touching the leper, although the text says, "Moved with pity, he stretched out his hand and touched him" (Mark 1:41). To contact a leper was to risk contagion, and according to Jewish law it made one legally unclean. In the Gladzor Gospels, however, Christ puts his hand on the leper's head. The gesture indicates the absolute power by which Christ worked. In the words of John Chrysostom, repeated in Armenian commentaries, by touching the leper, Christ "signified that he heals not as a servant, but as absolute master, for his hand became not unclean from the leprosy but the leprous body was rendered clean by his holy hand." It was important in the Gladzor Gospels to show a savior fearless in his concern for the diseased.

The Healing of the Woman with a Hemorrhage similarly involves Christ's contact with someone who was, in the eyes of the Jewish law, unclean (pl. 33). In the painting Christ is engaged by

Jairus, a synagogue official who begs him to come cure his daughter; the woman approaches from behind, touching Christ's hem. Ephrem the Syrian, ever popular with Armenians, observed that reaching out to touch Christ purifies the woman without making Christ unclean. "If fire purges unclean things without itself becoming dirtied, how much more would the power of his divinity cleanse without being made unclean?" Chrysostom ranked the woman's faith above that of Jairus, who thought he had to bring the physician to his house to effect his daughter's cure.

The Raising of Lazarus is the most dramatic of Christ's cures, the most complex in its iconography, and the most profound in its portrayal of Christ. The scene is very popular in medieval Christian art and the composition is standardized. In the Gladzor Gospels the Evangelist Painter follows established imagery in presenting the prayer of Lazarus's sisters in the foreground, disciples on the left, and amazed bystanders in the middle, while on the right, a servant opens the grave and unwraps the figure of Lazarus (pl. 57). The most important adjustment the painter has made to the standard composition is his reduction in the number of figures and his enlargement of Christ, who dominates the whole scene with his oversized halo and powerful speaking gesture.

The Armenian understanding of this event takes us to the heart of the Armenians' most serious difference with other Christians concerning Christ, a difference that is commonly but inaccurately summarized in the term *Monophysitism* (literally, a "single nature" belief). It is inaccurate because the point at issue for the Armenian Church is not whether there are one or two natures in Christ; they agreed there are two—the divine and the human. The point at issue is the manner in which the divine and the human natures are united in Christ and how one can describe that union. As noted earlier, Armenian theology held firmly to the formulation of the early Fathers of the Church, who invoked the simple analogy of liquids poured together: the divine and human were thoroughly mingled and fused, and inseparable in Christ. The Greek and Roman Catholic Churches, following the Council of Chalcedon in 451, had rejected the earlier metaphors of mixture and insisted that the natures remained distinct. The issue was given new life precisely at the time of the Gladzor Gospels when Roman Catholic missionaries arrived in Armenia preaching the distinction of the natures in Christ.

The Raising of Lazarus appeared to Armenians to be a vivid demonstration of their understanding of Christ's unity. Christ yelled out, "Lazarus, come forth." The words spoken by Christ the man and heard by the human bystanders penetrated to the world beyond to summon

Lazarus back from death to life. The unity of his voice demonstrated the unity of the two natures in him. "He called as man and raised as God. One was the voice of God and man, as he who called was man and God," according to an Armenian sermon used in the fourteenth century to refute the Roman Catholics. "It is not possible to divide the voice in two, nor can the two natures united in one voice be divided into two."

The solemn voice of Christ, then, resonates with divinity, and the illustration of the Raising of Lazarus would have carried this meaning in theological circles. The wide-eyed bystanders in the miniature divide their attention between the authoritative speaking gesture of Christ and the body of the youthful Lazarus, which emerges from the grave like a seed from its pod. A grand cosmic meaning is implied, as explained by Ephrem the Syrian in his comprehensive Syrian approach. When Christ robbed Hades of Lazarus, he announced the end of death's dominion over humanity. His tears fell like rain, penetrating the earth, his voice rolled as thunder, and Lazarus sprang up like a seed in the earth, as a token of the resurrection of all. Although it might seem too much to expect painters to picture mysteries that the theologians had great trouble describing in words, *The Raising of Lazarus* demonstrates how pictures could become enormously forceful expressions of abstract arguments. Often images make indelible impressions, even when words are difficult to follow.

THE HUMAN AND THE DIVINE IN CHRIST

The mystery of God in Christ enters into virtually every story in the Gospels. The issues were subtly framed in Armenia, and the Gladzor Gospels miniatures offer a surprisingly comprehensive statement of some of the complex aspects of the subject. *The Raising of Lazarus* shows the viewer that the two natures were so united that Christ could act and speak as one. In other miniatures the reader is reminded that the divinity in no way erased his humanity.

The story of the First Storm at Sea, with Christ asleep in the boat, was commonly used as proof of the unsleeping vigilance of the divinity (see pl. 32). The subject matter of the Gladzor Gospels' miniature of the Second Storm at Sea, however, had a special appeal to the painter T'oros of Taron; so much so, in fact, that he chose to include his inscription to the abbot Yesayi within his representation of the story (pl. 35). Instead of the more commonly shown moment in the story, Christ saving the sinking Peter, T'oros has chosen the earlier moment of the initial apparition of Christ on the water when the apostles exclaimed in fear: "It is a ghost!" (Matthew 14:26). Like a chorus, the apostles all make the same gesture of surprise as they peer over the

water at Christ on the waves. This choice calls attention to the debate on the reality of Christ's humanity. John of Yerzinka says the disciples were distressed because they knew that water could not sustain the physical weight of Christ's body. Peter, he tells us, climbed out of the boat in order to demonstrate, by physically embracing Christ, that Christ's body was of the same stuff as his own body. This was a long tradition among Armenian commentators in their argument with the "phantasiasts," who believed that Christ's body was only an apparition, not flesh and blood. The Armenian Church insisted Christ was of the same physical substance as the rest of us.

Christ was also understood to have both a human body and a human soul. This seems to be the intention of the miniature showing the Entry into Jerusalem and the Cleansing of the Temple (pl. 21). The Entry is shown twice in the Gladzor Gospels, and in many details T'oros repeats the iconography of his predecessor, who had already painted the scene on page 252. In one curious detail, however, he departs to show Christ riding simultaneously on the ass and the foal. He sits on the arched back of the snow-white ass while he rests his feet on her tawny, immature offspring. Although rare in Christian iconography, the double mount is literally the way Matthew describes the event: "They brought the ass and the colt, and put their garments on them, and he sat on them" (Matthew 27:7). The Gladzor exegete John of Yerzinka seized on this detail as particularly significant in defining the makeup of Christ. The ass and the foal, he wrote, stand for the harmony of the body and soul in the human nature of Christ, representing two elements "on which the Word sat, unifying them by his own person." Neither of the elements of his humanity can be discounted.

As Son of God, however, Christ was ever eternal and a member of the Blessed Trinity. This is stressed in the miniature of the Transfiguration, in which, quite exceptionally, the artist has introduced the dove of the Holy Spirit descending from the hand of God over Christ (pl. 16). Although the Transfiguration is extremely popular in Byzantine art, especially at this time, the dove does not appear because it is not mentioned in the Gospel text. Byzantine commentators analyzed the event for clues about the individual's encounter with the divine. Syrian and Armenian exegetes, in their more comprehensive approach, saw the event in the largest possible dimensions of salvation of the world, telescoping past and future as if everything were simultaneously present in the divine perspective. Christ in his Transfiguration is appearing to his apostles in the glory that he is going to have after his Resurrection; at the same time Moses and Elijah stand on either side of him testifying that Christ is the same Lord whom they had

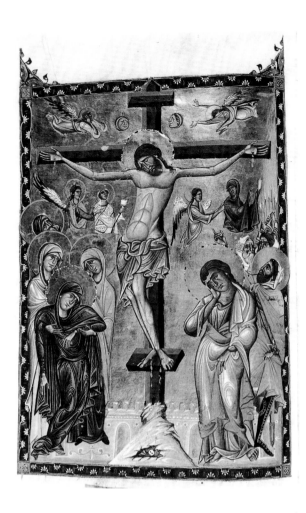

seen ages ago in the burning bush and the whispering breeze. John of Yerzinka also proposed that the mountain where the apparition took place was really in Paradise, and the artist illustrates this by adding a pair of trees arching to either side of Christ, another innovation in this picture. In other words, the Resurrection of Christ restores the glory of humankind's primitive existence in the Garden of Eden. Meanwhile, Christ himself in the Transfiguration resides in the unchanging glory of the Trinity: the Father is present in his hand and the Spirit in the dove spreading its wings over Christ.

No image in the Gladzor Gospels better embodies the spirit of the Armenian faith than *The Crucifixion* (pl. 59). Located at almost the end of the manuscript and portraying the most central act of Christ's redeeming work, it is in many ways the climax of the whole program. While the Crucifixion is one of the most commonly represented subjects in the history of Christian art, its rendition here is unique and directs one to the distinctly Armenian reading of the event.

The artist has reduced the scene to its essential elements, in contrast to many depictions of the event (fig. 9). The huge cross stretches almost to the four edges of the picture against a plain gold ground. On this cross the figure of Christ stands more than hangs, for he is virtually erect, although his closed eyes and his pierced side tell the viewer that he is dead. This is in marked contrast with the sagging body of Christ ubiquitous in contemporary European and Byzantine representations. Clearly, it was important to show Christ as powerful even in death, and this is a common Armenian theme.

FIGURE 9
The Crucifixion.
Queen Keran Gospels, Sis, Cilicia, 1272.
Jerusalem, Church of Saint James, Ms. 2563, fol. 362v.

To the Armenian viewer the Crucifixion would have immediately recalled the hymn he chanted three times at every celebration of the mass, the Trisagion Hymn of the First Entrance:

> Holy (are you), God,
> Holy and mighty,
> Holy and immortal,
> Who were crucified for us.
> Have mercy on us!

The Greek Church uses the same hymn but without the fourth line, insisting that the hymn is addressed to the Trinity. In Armenia, however, the verses are addressed to Christ as God on the cross, and they proclaim his might even in death. This is a very authentic part of Armenian faith enunciated in very bold terms already in the early Armenian catechism, *The Teaching of Saint Gregory the Illuminator*. The fact that Christ died with a loud shout proves to Gregory that he went willingly to his death and that he died in power, not in weakness. Indeed the Sunday hymn of the Resurrection in the Armenian Church refers to his shout from the cross as the roar of a lion that resounded even in Hades. A sermon text used in the fourteenth century expresses the Armenian belief in the divine presence in Christ during his Crucifixion and at his death. "The Godhead was not separated from the manhood, neither during the passion nor in death, for it did not suffer nor did it die. . . . I confess God who suffered and boldly say: God was crucified in his body and he was on the cherubic throne; God died in his body and was glorified with the Father." *The Crucifixion* of the Gladzor Gospels invites the viewer to contemplate the presence of the almighty God still powerful in the dead Christ.

CHRIST AND THE CHURCH

Besides addressing the issues of Christ's personality and nature, the Gladzor Gospels examined a number of situations that define his relationship to the hierarchy of the Church. To the church men, who made the book for their own use, ecclesiastical order and succession were paramount. The Church was the guarantor of Armenia's spiritual identity.

The Gladzor Gospels opens its illustration of the life of Christ with forty-one enthroned figures of the ancestors of Christ (pls. 9–12). Occupying eight full pages, this constitutes the richest treatment of the Ancestors of Christ in medieval manuscript art, whether in the East or

the West. Brilliantly robed in tunics and cloaks that alternate vermilion and azurite, the ancestors, some with crowns and some with haloes, assume uniform frontal poses. They hold scrolls of authority in their left hands while they gesture in greeting with the right. The enthroned Christ, longhaired and youthful, begins and ends the series. Rare as they are in other traditions, the ancestors provide a common subject in Armenian manuscripts, and they announce a particularly Armenian message that goes beyond the literal burden of the text.

Matthew traces the genealogy of Christ through David to insure him a royal ancestry, but Armenian commentators insist that Christ inherited not only royalty but also priesthood from his ancestors, who came both from the house of David and the house of Levi. This nonscriptural version of events effectively embedded Christ in the Armenian *nakharar* system, a feudal structure in which class was expected to be a matter of birth. After the Arab invasions had interrupted many noble family lines, the Armenians invented an ancient Jewish ancestry for their new royal families, the Bagratids and the Artsrunis. Furthermore, unique among Christian communities, the Armenians included the hierarchy of the Church in this feudal structure so that the priesthood was inherited within certain families. Christ's claim to the spiritual traditions that he gave his Church had to be founded on tangible family connections. The authenticity of Christ's lineage guaranteed his right to inherit the fullness of the Old Testament traditions as king and priest, and this inheritance he will pass on to his Church.

Several other miniatures speak of Christ's role in founding and governing the Church. *Christ with the Mother of James and John* may be seen as a caution against abuse of family influence in the Church (pl. 19). With her sons behind her, the woman falls on her knees before Christ. According to the Gospel, when the mother of James and John petitioned Christ that her sons sit "one at your right hand and one at your left in your kingdom," Christ turned her ambition into a lesson in humility: "Whoever would be great among you must be your servant." Since the mother of James and John was identified as Mary's sister, Salome, Armenian commentators imagined that the two apostles thought they deserved special preferment because they were related to Christ. The miniature, therefore, stands as a counsel to the clergy against personal and familial ambition, a counsel especially appropriate in a society where holy orders tended to be hereditary.

The Blessing of the Children is concerned with apostolic succession in the Church. In the text of Matthew 19 : 13–15, when some of Christ's audience presented their children for a blessing, the disciples shooed them away. "Let the children come to me," Christ intervened, "for to

such belongs the kingdom of heaven." The lesson in humility could not be more straightforward and simple. Curiously the artist in the Gladzor Gospels has very boldly rewritten the story (pl. 18). The parents are nowhere to be seen, and instead of pushing the children away, the apostles are presenting them to Christ. Moreover, a certain ecclesiastical character is given to the scene by dressing the apostles in stoles, and by showing both Peter and the first of the children tonsured. This unexpected turn in the story is found in the commentary of John of Yerzinka. The blessing of the children was no ordinary blessing; rather, it was the ordination of the next generation of clergy to secure the continuity of orders in the Church. John goes on to explain that one of the children was Ignatius of Antioch, the martyr-to-be who was credited by Yesayi of Nich with authoring the Trisagion, the most characteristic of Armenian liturgical hymns. Thus, in this image the viewer is instructed that the succession of clergy within the Armenian Church and its sacred liturgical traditions go back to Christ himself.

Money is an important subtheme in the Gladzor life of Christ, and it figures in a number of the miniatures. In the parable of the cunning steward Christ introduced the subject by discussing a dishonest steward who faced dismissal by his lord. Before losing his position, the steward went about revising the accounts to ingratiate himself with his master's debtors. The lesson prescinds from the steward's dishonesty to turn the Christian's attention to the proper use of money: "Make friends for yourselves by means of unrighteous mammon (that is, money), so that when it fails they may receive you into the eternal habitations" (Luke 16:9). In the miniature T'oros of Taron shows the steward appearing before his master in the top register and making arrangements with the debtors in the lower register (pl. 47). The steward typifies just Christians purchasing reward in Heaven with the proper use of their money. The master is shown as Christ in a chamber of gold, and the steward and debtors are haloed. At a time when Mongol overlordship was impoverishing every institution outside of the Church, the careful use of money must have been a very real preoccupation. The most prudent use of money was to invest it in tax-free monasteries.

The miniature of the Ascension presents the most complete symbol of Christ's relationship to the church, and it is significant that T'oros of Taron has included his signature under this particular miniature (pl. 50). The picture repeats the standard composition, dividing the event into an earthly and a heavenly zone. Above, Christ mounts to Heaven amid a swirl of angels. Armenian hymns for the feast of the Ascension emphasize that he ascended in his physical body—that of Adam—so that he might pave the way for humankind's similar ascent. Before

human nature can ascend into Heaven, however, it must be incorporated into the body of the Church, illustrated below. Although the Virgin is not mentioned in the Gospel account, she was commonly inserted into the image because of her identification as the mother of the saved and a symbol of the Church. Further nonhistorical details are included in the apostles. T'oros of Taron has inserted Saint Paul, who joined the apostles later as missionary to the Gentiles, in the first row, third from left. Furthermore, Paul and the four evangelists are shown clasping the books that they were yet to compose, alluding to their future teaching mission. Only through joining the apostolic church on Earth can one join Christ in his ascent to Heaven.

WOMEN IN THE LIFE OF CHRIST

Women are extremely important in the Gladzor life of Christ; twenty-one of the fifty-six miniatures involve women, and many of these show them in direct interaction with the savior. In one of the miniatures discussed above the mother of James and John plays, or attempts to play, a part in advancing her sons by virtue of her family connection with her nephew, Christ. This is characteristic of the role many of the women are given in the Gladzor Gospels. Cousins Mary and Elizabeth meet to arrange matters of family succession; Salome conspires for her mother's advantage to arrange the murder of John the Baptist; Mary Magdalene, by her insertion into the family of Christ, takes on priestly and apostolic roles. This offers an interesting parallel to the role of women in contemporary Mongol manuscripts who are frequently shown plotting family advancement. Women in the Gladzor Gospels also represent the "other," that is, non-Christian communities, which will be discussed separately below under the rubric "The Church and the Nations."

Mary, Christ's mother, appears in eight miniatures in the Gladzor Gospels, but curiously enough the scene of the Nativity of Christ is not among them. Instead she has been included in the otherwise totally male series of the Genealogy of Christ where she shares the last page with Joseph and her child, Jesus (pl. 12). This is a significant shift. In keeping with Armenian preoccupation with lineage, the Gladzor Gospels emphasizes Mary's role as the final link in Christ's ancestry over her part in the story of his miraculous birth. Two of the standard subjects of the infancy of Christ, however, are included in the Gladzor Gospels, the Annunciation (pl. 43) and the Visitation (pl. 44), and they form a kind of diptych of full-page pictures of similar format. *The Annunciation*, an image of dazzling colors against a gold ground, locates Mary's encounter with the angel in a garden with an arched tree overhead and water flowing from a well into a ves-

sel below. As elsewhere in the manuscript, the image contains resonances of hymns familiar in the Armenian Church. "Living Paradise of delight, the tree of immortal life," she is called in one hymn; in another, "Living Eden, soil of the immortal plant, the verdant place of the flower born of the bosom of the Father." Again, the "fountain of living water" and the "golden pitcher" are metaphors attached to Mary. Another detail made almost invisible by the flaking of the pigment, the dove with outstretched wings over Mary's head, also takes us to the Armenian liturgy. This is the dove of the Holy Spirit, which also appears in *The Transfiguration* (pl. 16) and in *Christ Reading in the Synagogue* (pl. 45). The words of the angel's promise—"The Holy Spirit will come upon you and the power of the Most High will overshadow you" (Luke 1:35)—have a special place in the Armenian liturgy. At the conclusion of the preamble ceremony in which the bread and wine are prepared for the Eucharist, the priest repeats this verse three times, emphasizing the parallel between Christ's incarnation in Mary and his reincarnation in the Sacrament.

Mary's role is specified further in *The Visitation* (pl. 44). In it she embraces her cousin Elizabeth, already six months pregnant with John the Baptist. Behind Mary is one of her virgin companions who has followed her on her journey, while behind Elizabeth sits the aged father of John the Baptist, Zachariah the priest. His presence is unusual in the scene and points to his importance in the *Armenian Infancy Gospel*, in which he is made into the High Priest. This makes him a special link in the transmission of Old Testament priesthood, for being High Priest, he passed the priesthood on to his son John the Baptist, who in turn gave it to Christ when he baptized him. When the two pregnant women meet, Jesus and John also meet for the first time, and Elizabeth remarks, "The babe in my womb leaped for joy" (Luke 1:44). The Armenian life of Christ makes salvation a family affair, and in this image it is the women who move the action along.

Quite opposite from the story of Mary and Elizabeth, the Beheading of John the Baptist tells of a mother-daughter plot of a gruesome murder. In the Gladzor Gospels miniature (pl. 13), the story reads clockwise from the bottom, where four banqueters sit around a semicircular table celebrating Herod's birthday. Their attention is drawn to the right where Salome, after her clever dance, repeats her mother's plea, "Give me the head of John the Baptist here on a platter" (Matthew 14:8). Above to the right, in a separate scene, the actual beheading takes place with blood spurting from John's neck. In the last scene—below on the right—the executioner presents to Salome the head of John on the same platter that moments before had stood on the dining table.

The painting is distinguished by what it omits and by what it adds to the standard iconography: Salome's dance has been dropped and a pair of demons has been added—two ugly creatures with birdlike bodies and black hairy heads. These are labeled Beliar Shun on the left and Sadayel on the right. The story is made into a diabolical plot. Salome, according to Chrysostom, had given herself to the devil. As Satan found he could overcome Adam through his wife, so could he overcome Herod through his wife, Salome's mother. Here woman is cast in her most sinister role.

Another kind of subplot can be followed in the story of Mary Magdalene, which is told in the Gladzor Gospels in three illustrations. All three are anointings of Christ that put her in an intimate relationship with him and his family. The first is her repentance in *The Anointing of Christ at Simon's House*, in which she washes his feet and wipes them with her hair (pl. 46). Simon the Pharisee makes a gesture to protest, since he inferred from Christ's acquiescence that he did not know that Mary was a sinful woman; however, Christ proclaimed, "Her sins, which are many, are forgiven, because she loved much" (Luke 7:47). Armenians liked to reflect on the psychology of her repentance and the courage it took to perform public penance before Simon and the apostles, and a sermon containing her troubled soliloquy before the confrontation had wide circulation.

The Gospel text leaves uncertain the identity of the woman involved in the Anointing of Christ at Bethany. Nevertheless, the Gladzor commentator John of Yerzinka had no doubt it was Mary Magdalene. He saw a progression in the story in that on her conversion she anointed Christ's feet, at Bethany shortly before his passion she anointed his head, and after his death she came to the tomb with his mother and another Mary to anoint his entire body. The anointing on the head is a sacrament, he asserts, giving Mary Magdalene a truly priestly role. In the miniature she is placed opposite the protesting apostles whom Christ is silencing with his raised hand (pl. 38).

The Women at the Tomb departs from Byzantine iconography by showing three women; this is, however, typical of a long-standing Armenian tradition of including the Mother of God, shown on the left, among the women (pl. 28). The woman on the right, next to the gleaming angel, should be identified as Mary Magdalene. The importance of this subject stems from its inclusion in the weekly Armenian celebration of Matins on Sunday, which is called the Office of the Myrrh-Bearers. The hymn of Matins makes the women join the angel in announcing Christ's resurrection:

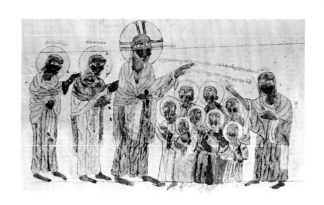

By the holy stone sat the marvelous one and cried aloud,
And the oil-bearing women announced joyfully:
Christ did arise, Christ did awake,
Out of the new tomb, out of the virgin tomb.

Mary Magdalene and her companions thus became proto-apostles, anticipating them in spreading the news of Christ's victory over death.

The miniature of the Raising of Jairus's Daughter rather unexpectedly involves a statement about all womankind (pl. 34). The composition of the image assimilates it into images of the Anastasis, in which Christ raises Adam and Eve from the dead. Jairus's daughter, beneath a brilliant panel of vermilion, has been placed in a low bed that resembles the sarcophagus of Adam and Eve, while Christ, beneath a panel of gold, leans on a staff like the cross he holds in scenes of his Anastasis. The Gladzor commentator was aware of the connection; John of Yerzinka called the daughter of Jairus a type of Eve, who was in a sense Adam's daughter, in that she was born of his side. The raising of Jairus's daughter is thus made into a pendant to the subsequent scene of the Raising of Lazarus: woman and man are equally called back from the dead by a Christ who is lord of the living and the dead.

THE CHURCH AND THE NATIONS

In another group of miniatures in the Gladzor Gospels Christ encounters a number of different ethnic groups; these images serve to define the church's relationship to the rest of the world. Women figure prominently in these stories as symbols of the "other," or outsiders.

When Christ ventured into the idolatrous Gentile territory of Tyre and Sidon, a woman seeking a cure for her daughter approached him, in an episode known as the Petition of the Canaanite. The Gladzor Gospels gives the story particular importance by enlarging to full-page format a minor scene in the eleventh-century model (pl. 14; fig. 10). Furthermore, *The Petition of the Canaanite* gives a subtle twist to the narrative. Most medieval artists chose to illustrate either the woman's humble kneeling before Christ or the sickness of her daughter. Instead both the Vehap'ar and the Gladzor Gospels show the first moment of the woman's encounter with Christ as she calls out to him over the heads of the apostles, who are embarrassed by her persistence. This focus on the moment of meeting turns the viewer's attention to the ecclesiological dimension of Christ's relationship with the non-Jewish woman. The Gladzor exegete John

FIGURE 10
The Petition of the Canaanite.
Vahap'ar Gospels; Lesser Armenia,
early eleventh century.
Yerevan, Matenadaran, Ms. 10780,
fol. 40v (detail).

of Yerzinka identifies the woman as the Church of the Gentiles who has recognized her savior and called out for deliverance. Leaving the idolatry of Tyre and Sidon, she became the mystical spouse of the Word.

The conversion of outsiders is also the theme of *Christ and the Samaritan Woman*, in which a particularly contemporary note is introduced (pl. 54). Jews regarded the Samaritans as heretical and would have nothing to do with them. In the lengthy story in John 4:1–42, Christ disregards the social barrier to enter into conversation with the Samaritan woman. Rejecting the mutually exclusive claims of both the Jews and the Samaritans, Christ looks forward to a spiritual worship into which the whole world would be invited.

The miniature has rolled several successive moments of the narrative into one. The core of the image is Christ's encounter with the woman of Samaria, shown in the center drawing water, from which he requests a drink. Above the well the disciples are returning to the scene with a basket of food. To the right the Samaritans are exiting their city to hear the novel message of the prophet. They follow a gentleman with a fur-lined coat and a pointed hat who must be identified as the woman's "husband." His dress is one of the few contemporary allusions in the illustrations, for the Mongols introduced this kind of costume into Armenia. The miniature tries to express the universality of Christ's mission by extending it even to the Mongols. Optimism that the Mongols might be won over to Christianity was still alive in early fourteenth-century Armenia.

Two successive miniatures of Christ's trial address the alleged guilt of the Jews in Christ's death and thus address the Church's attitude toward the Jews. In the first, Pilate, seated against the white ground of the parchment, receives a scroll from a messenger in a pointed hat while a hostile crowd looks on (pl. 26). *The Message from Pilate's Wife* illustrates an apparently trivial incident passed over in most pictorial versions of the life of Christ. Matthew relates, "While [Pilate] was sitting on the judgment seat, his wife sent word for him, 'Have nothing to do with that righteous man, for I have suffered much over him today in a dream'" (Matthew 27:19). Pilate's wife, Procla, was believed to have been a Jew, and Chrysostom thought she was trying to prove Christ's innocence and recall Pilate from his course of action. The Gladzor commentator John of Yerzinka goes one step further: "I think the woman is a symbol of the sincere congregation of the Jews who were not interested in Christ's death."

In the following miniature (pl. 27), Procla's innocence is contrasted with the guilt of the majority of the Jews. In *Pilate Washing His Hands* a humble Christ is spectator while his case is

decided. In the upper register Pilate is seen to excuse himself of guilt by washing his hands, while the Jews in the lower register readily assume the guilt for themselves and their progeny, calling out, "His blood be on us and on our children!" (Matthew 27:25). The crude anti-Semitism of the story is given a nuance in the commentaries. Both Chrysostom and John of Yerzinka recognized that in Christian teaching a parent's sin cannot be imputed to his children, and that many Jews did in fact embrace Christ's teaching. They concluded then that it was not their ancestors' curse that condemned contemporary Jews but their continuance in the sin of disbelief.

CHRIST IN THE RITES OF THE ARMENIAN CHURCH

Alongside its proclamation of Armenian belief concerning Christ's natures, the miniature of the Crucifixion supports Armenia's tradition of using unmixed wine in the Eucharist (pl. 59). An unusual detail is the separation of the streams of blood and water that flow from the side of Christ. In this detail the painting argues with the Roman Catholics and Greeks about their practice of diluting the Eucharistic wine with water. Roman Catholic missionaries in Armenia were raising the issue at this time, pressing for conformity in ritual as well as in creed. The painter's care to show separate streams of water and blood spurting from Christ's side involves a polemical argument. For Armenians, the water and blood symbolize not the water mixed with wine in the chalice, as in the Roman Catholic interpretation, but the distinct sacraments of Baptism and Eucharist.

A number of other illustrations of the life of Christ touch on similar matters of Armenian ritual. The interpretation of the Gospel accounts thus confirms the antiquity and authority of Armenian ways of performing the rites in the face of the missionary threat to supplant them with Roman Catholic customs.

Christ Reading in the Synagogue is allotted the special importance of a full-page miniature (pl. 45). A pair of arches enframes Christ in a zone of gold and the congregation of the synagogue in a zone of white. The miniature departs from the customary illustration of the subject by showing the moment when Christ "opened the book and found the place where it is written, 'The Spirit of the Lord is upon me, because he has anointed me to preach good news to the poor'" (Luke 4:17–18). As in *The Transfiguration*, the Spirit is shown hovering over the head of Christ in the form of the dove. Before Christ the people look up in attention; the man at the top is the synagogue attendant who has just delivered the book of Isaiah to Christ.

Detail of Plate 4.

The personal element in the painting is inescapable. The Gladzor Gospels was made for the abbot Yesayi, which is the Armenian spelling of Isaiah, and the abbot's special interest in the prophet Isaiah is clear from the verse-by-verse commentary he wrote on the work. In commenting on Isaiah, Yesayi, in effect, continued Christ's work. In the miniature, moreover, Christ holds the codex on a folding reading stand of the kind traditional in the Armenian Church, known as a *grakal*. He thus endorses the specific manner of conducting the reading in the Armenian liturgy.

Further allusions to Armenian ritual can be found in the picture of the Marriage at Cana (pl. 53). The story of the miraculous transformation of water into wine was the passage read at weddings in the Armenian Church, and the bride and groom in the miniature wear crowns that were customary at Armenian weddings. At the left, Christ is shown taking part in the celebration, drinking from a conical beaker full of red wine. Although there are several passages in the Gospels where Christ is said to have partaken of food or drink, most Christian art curiously omits showing him in the act of eating or drinking. At this Armenian wedding, Christ himself participates in the wedding celebration.

The image also makes direct reference to the Eucharist. Ephrem the Syrian, a favorite source among the Armenians, remarked, "In the first of his signs (that is, miracles) he made wine, giving joy to the banqueters, in order to show that his blood would give joy to all generations of the Gentiles." The allusion to the Eucharist is made explicit in the miniature by placing a grand oversized chalice full of wine in the middle of the composition.

The specific Armenian manner of celebrating the Eucharist is referred to in two other miniatures. The Last Supper is loaded with symbolic allusions, identifying Christ as the Lamb of God and making his last meal with his apostles an anticipation of his sacrifice on the cross. In the representation of the meal believed to be the first Eucharist, however, the painter has carefully shown a pair of chalices containing bread in the wine (pl. 22). The same detail may be observed in *Christ's Apparition at the Sea of Galilee* (pl. 60). In contrast to the Roman Catholic rite in which bread and wine were received separately in the Communion of the clergy and the laity were allowed only the bread, the Armenians abided by the very ancient tradition common in the Churches of the East of Communion by commixture; that is, the bread is broken and dropped into the chalice and offered to the faithful on a spoon. These miniatures, showing bread in the chalice, therefore, like *The Crucifixion*, contain a polemical defense of the apostolic origins of the Armenian way of conducting the sacrament.

CHAPTER FOUR:
CONCLUSION

*T*he artists who undertook the design of the miniatures for the Gladzor Gospels did not take their assignment lightly. They found the model for the program and for many individual compositions by consulting the venerable Vehap'ar Gospels. To the artists, this eleventh-century manuscript represented the authentic Armenian tradition before the coming of the Mongols and the infiltration of Roman Catholic missionaries. They copied many of the old images faithfully, accounting for three-quarters of the program, while they expanded or filled out others. To this core of imagery they then added a number of subjects of general currency in the Christian world such as the Last Supper, the Women at the Tomb, and the Ascension.

At each step in this process the artists seem to have been guided by theological discussion then in progress in the monasteries of the province of Siunik' in the circle of a leading champion of Armenian traditionalism, Yesayi of Nich. Being monks, they were also familiar with Armenian ritual and its rich hymnology as well as sources popular in the classrooms of the monasteries. The result is a very consistent life of Christ that has been woven into the basic fabric of the Gospel text. This version of the story is often archaic, going back to interpretations of early Syria and Armenia, and often polemical, insisting on the interpretations of the natures of Christ proper to the Armenian Church. The artists also succeeded in placing Christ in the contested social framework of early fourteenth-century Armenia, which was their greatest accomplishment. Christ belonged to the Armenians. It remains to look at what happened to that message and to the Gladzor Gospels once the manuscript was finished.

After Yesayi's death in 1338, his students continued to dominate Armenian scholarship throughout the fourteenth century. Among his students were the leaders of the next generation of *vardapets*, including Yovhannes of Yerzinka, Yovhan of Vorotn, and Yovhan of K'rnay. All three "Johns" devoted their lengthy careers to the consideration of issues raised by Roman Catholic missionaries in Armenia, ending up on different sides of this major ecclesiastical confrontation.

John of Yerzinka played a particularly important role in the Armeno-Catholic disputes. His commentary on Matthew stands firmly in support of Armenian tradition; it has guided our reading of many of the miniatures in the Gladzor Gospels. After completing this work, John attended a council in Adana, Cilicia, which had as its goal the adjustment of Armenian practices to conform to Roman Catholic ones. Whatever his role might have been in that effort, he returned to work at anti-Catholic Gladzor. Soon, however, he was working with an Italian Catholic missionary, Bartholomew of Bologna, on translations from Latin into Armenian.

Detail of Plate 37.

His openness to new ideas was such that scholars have disputed whether he indeed was a Roman Catholic.

In the religious and intellectual turmoil of the fourteenth century, Yesayi's students had to grapple with the choice between Roman Catholicism and traditional Armenian Christianity. The John identified with K'rnay—a Roman Catholic monastery by the end of the fourteenth century—produced Armenian translations of Thomas Aquinas, while another John returned to his birthplace, Vorotn, to head a monastic school that applied Thomist theology to the defense of specifically Armenian positions.

Despite some successes, Catholicism did not manage to take firm root in Armenia until the seventeenth century, by which time the fourteenth-century Uniate movement had been forgotten. Meanwhile the Gladzor Gospels remained important to many Armenians. A generation after its completion, Awag, an artist from Gladzor, copied virtually the entire program of the Gladzor Gospels in a manuscript he completed in Sultaniye in 1337. The same year, the Gladzor Gospels was bought by Vakhakh, an Orbelian princess married to a Proshian prince, who wrote in it a prayer that she and her children and her children's children might enjoy it "to a ripe old age." It is Vakhakh's colophon, mentioning the manuscript's completion at Gladzor, that gives the book its name. During the terror of Tamurlane's invasion of Armenia (1387–1389) the book fell into foreign hands, and Vakhakh's progeny ransomed it "after much expense and effort." At that point (1393–1404), the family gave the book to Geghard, an ancient monastery and the site of the Proshian mausoleum. The monks swore an oath to keep the manuscript forever, adding, "Whoever dares and endeavors to remove it shall be judged by God and all the saints, and shall receive the lot and portion of Cain and Judas and the crucifiers, and forever suffer and be tortured even as Satan, and all humanity shall curse and condemn him."

Nevertheless, the Gladzor Gospels did leave Geghard. In 1605 the Persian shah Abbas ordered a mass deportation of Armenians to his capital, Isfahan, where he settled them in a quarter they called New Julfa, in honor of the Armenian city in which most of them had resided. The Armenians of mountainous Siunik' do not seem to have suffered this deportation. While the Armenians of New Julfa prospered as merchants, however, they maintained ties with their homeland, treasuring in particular venerable manuscripts, among them the Gladzor Gospels. The manuscript was in New Julfa from at least 1628 until it came to the University of California, Los Angeles (UCLA), in 1968. It must have been greatly esteemed, since its illumination was copied in several other handsome manuscripts, including one in the J. Paul Getty Museum,

Ms. Ludwig I 14, of 1637–1638. Perhaps it already belonged at that time to the New Julfa church of Saint George, founded by the great merchant Khojay Nazar. In 1824 the congregation of Saint George gave the manuscript to its priest. It passed to at least one more priest before coming into the possession of a physician and amateur historian, Caro Minasian. The book may well have come to Dr. Minasian as much of his extensive library did, as an offering from a grateful patient who knew of the doctor's love of old books and manuscripts.

Dr. Minasian sold most of his collection to UCLA, with the Gladzor Gospels being an exception. Mindful of the note written by the monks at Geghard cursing anyone who might sell the manuscript, he was careful to separate it from his collection and to offer it to the university as a gift.

For centuries, this Gospel book had comforted Armenians as a tie to their past; as it changed hands, owners recorded in it their expectations. Some expected to benefit by being remembered in the prayers of later users or by enjoying the life-giving spiritual gifts of the book. Others expected the book to be "a protector and deliverer from evil."

By Dr. Minasian's time, expectations had changed. Although he may have thought of the manuscript as a force not to be challenged, Dr. Minasian also thought of it as part of his collection of historical documents, an object that ought to belong to a fine research library like that at UCLA. The Chancellor of the university, Franklin Murphy; University Librarian, Robert Vosper; and Director of the Near Eastern Center, Gustav von Grunebaum, had all demonstrated their commitment to the value of Dr. Minasian's collection by seeking to buy it. Inspired by Professor Avedis K. Sanjian, Alex Manoogian contributed toward the purchase. Rather than buying something for the good of his soul or something to show off his wealth, this Armenian Maecenas of Detroit spent his money to encourage the scholarly understanding of Armenia, a contribution in keeping with his many gifts in support of Armenian culture throughout the world.

The Gladzor Gospels, as a part of a research library, has taken on a new role, quite distant from its origins as a sacred book. Paradoxically, this new status reopened the book, and especially the meanings of its illustrations. The exhibition of this manuscript in honor of the seventeen-hundredth anniversary of the Christianization of Armenia is in many senses the result of the Gladzor Gospels' finding a new home, as one of the treasures of Armenian Los Angeles.

5

ՍՈ թողացէ ենեյերդկայնելզոյ կանոնագպատեան Եւ
յայտնապէսզդպատ ունեճենգդևայատես ֆվերայերդկա
անսիարոբէ գուանգատ ուրասապգ ջվեջգաւոն ֆերկա
լդ արդրապանդ երբխաառեստկեսայ յառա ջ սեն ապո յ
յերկկորթենկ յերրորդն Եւ յասայ կարպատխազո ց
էալ Բնթբենս ֆֆելք գկաիարածգրոդ գ ապատրպա ֆար
ֆեր Թողորդըուգաանէ ԹԷ յորման ի ֆֆգուջկանմա ց
կայլքԹեա Ա յապիսինեգ եջեառա ֆֆինս յայոտեԹերո
պեա ատա ֆ ուրստ ԵւժեԹերկրորես յերկորդգուէ
Եւ ոպսյելնսմեԷգ ք Եսին Ա րզբ ԹԷ զագեպալզ ֆեր ֆ
աաեն յորու ֆֆերպակամեգեէս կա յորես ֆաոոոպ ֆատ
եկ ամ ֆէ էագեֆէ ԵԹ ֆ որ ֆ աժֆ ֆֆ ֆ գոր ֆ անգոր մսֆֆ ստա
ուգ առ ատ գա գ անգ ֆֆ երն յերսրապս եջ եր ֆտ ֆ պապր ֆ սսան ֆ ել
յորսափ ուդու յ Եֆամֆ ան ֆ գոր ծ առագ յո ֆ ֆ ոու խ ֆ ֆ ֆ ստ ա ու ֆ Ե
գ ատա ֆ սակ ց ա գ ֆ ֆ ֆ ֆ ֆ դ տեգ ե ս ե գ ֆ ն ա ֆ ֆ կ ա ֆ մֆ ֆ ֆ ֆ ՝ր ֆ գոր կ ա րֆ ֆ
ա գ յորդ ֆ ֆ ն ե ր ֆ ֆ արսր ֆ ֆ տ աֆ ֆ ոգ ս ա ֆ ֆ ֆ ֆ ֆ է ֆ Ե ֆ ֆ ա ա գ ե ս ա ֆ ֆ ե ր ա տ ֆ կ ֆ ֆ ֆ ֆ ֆ
ֆ ս տ ա ս գ ե ֆ ո ֆ ֆ ֆ յ ո ր ս ֆ ֆ ֆ ֆ ո ֆ ֆ գ ե ո ֆ ֆ Ե ֆ ֆ գ ֆ ե ֆ ֆ ե ֆ ֆ ֆ յ ա ֆ ս
ա գ ֆ ս ֆ յ ո ր ֆ ա ֆ ֆ տ ա ր ա ս ֆ ա գ ո ֆ ֆ ֆ ֆ ֆ ֆ ֆ ֆ ֆ ե ֆ ֆ ֆ գ ֆ ֆ ֆ ֆ ֆ ֆ ֆ ֆ ֆ ո ֆ ֆ ֆ ֆ ֆ
ֆ ս ֆ ա ֆ ֆ ֆ ֆ ֆ ֆ ֆ ֆ ֆ ֆ ս ֆ ֆ ֆ ֆ ֆ ֆ ֆ ֆ ֆ ֆ Ե ֆ ֆ գ ֆ ֆ ֆ ֆ ֆ ֆ ֆ ֆ ֆ ֆ ֆ ֆ ֆ ֆ ֆ
ֆ խ ո ֆ ֆ ֆ գ Հ ա ն ա գ ֆ ֆ ֆ
ա ա գ ե ֆ ֆ ֆ ֆ ն ֆ գ ֆ ֆ ֆ ֆ ֆ ֆ ս ֆ ֆ ֆ Ր Ղ Լ ֆ ե ֆ

PLATE 3
Canon Table Painter, *Canon 1.*
Gladzor Gospels, p. 8.

PLATE 4
Canon Table Painter, *Canon 2.*
Gladzor Gospels, p. 9.

16

PLATE 5
Canon Table Painter, *Canons 6–7.*
Gladzor Gospels, p. 16.

PLATE 6
Canon Table Painter, *Canons 8–9.*
Gladzor Gospels, p. 17.

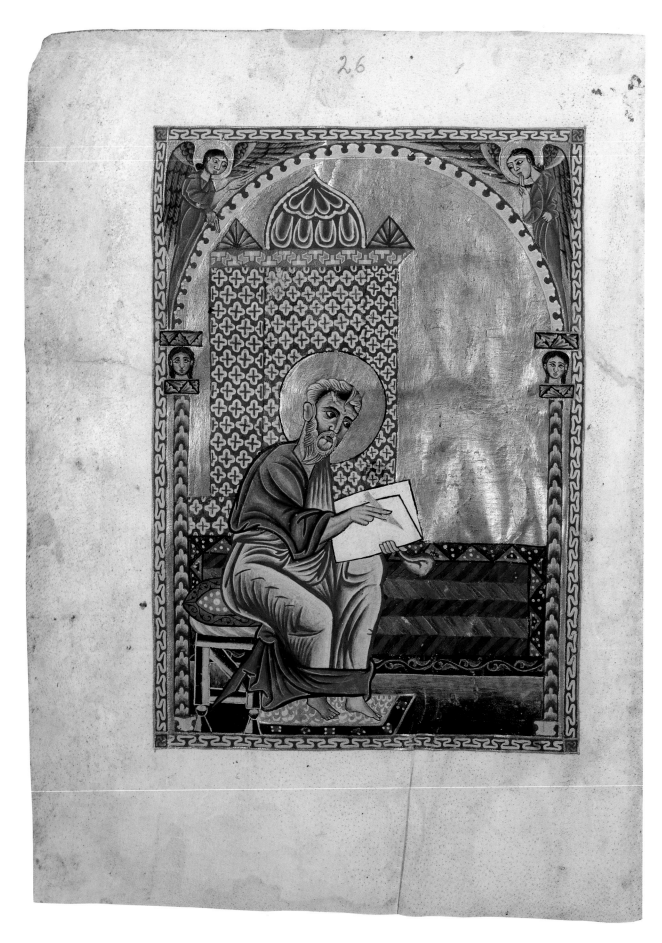

PLATE 7
Evangelist Painter, *Saint Matthew.*
Gladzor Gospels, p. 26.

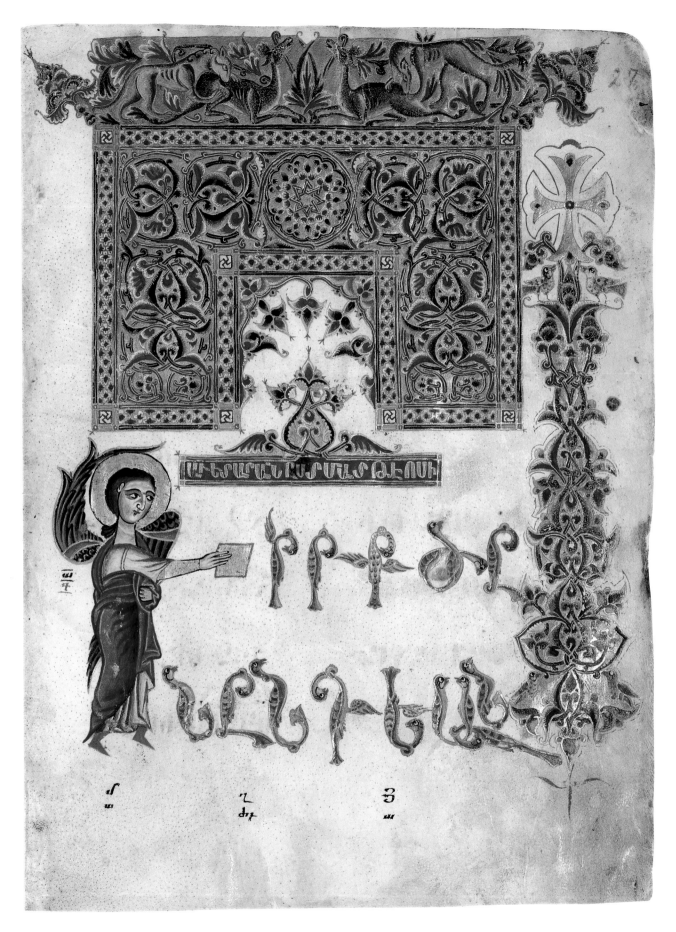

PLATE 8
Evangelist Painter, incipit page.
Gladzor Gospels, p. 27.

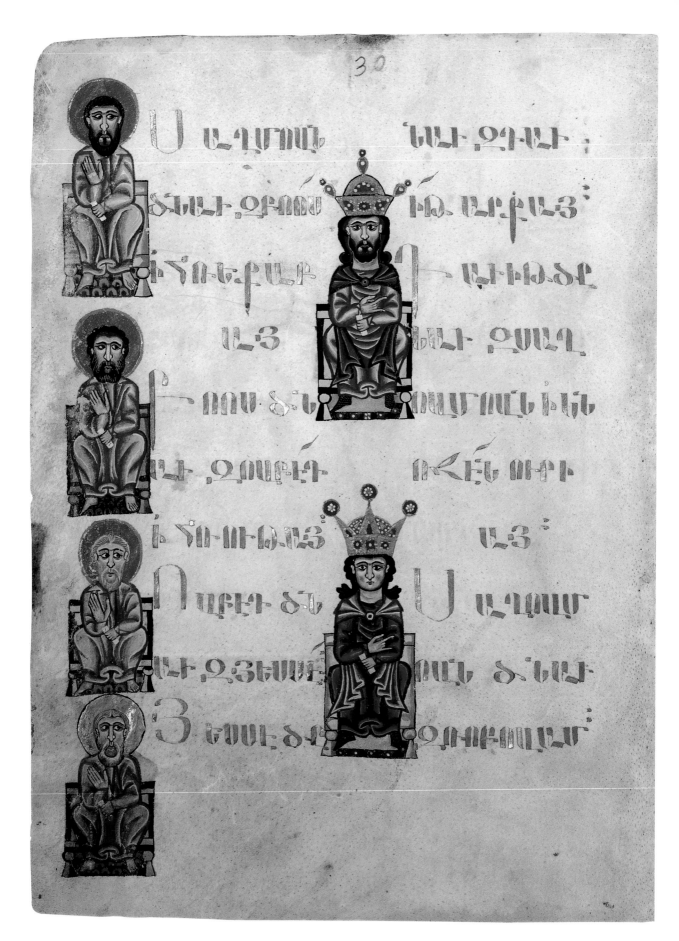

PLATE 9
Evangelist Painter, *The Genealogy of Christ.*
Gladzor Gospels, p. 30.

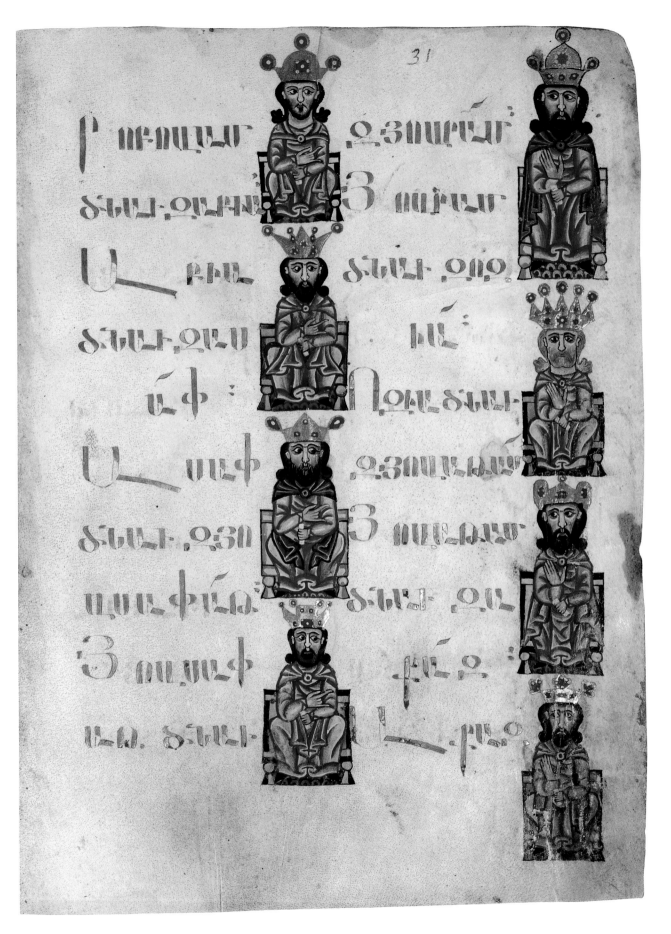

PLATE 10
Evangelist Painter, *The Genealogy of Christ.*
Gladzor Gospels, p. 31.

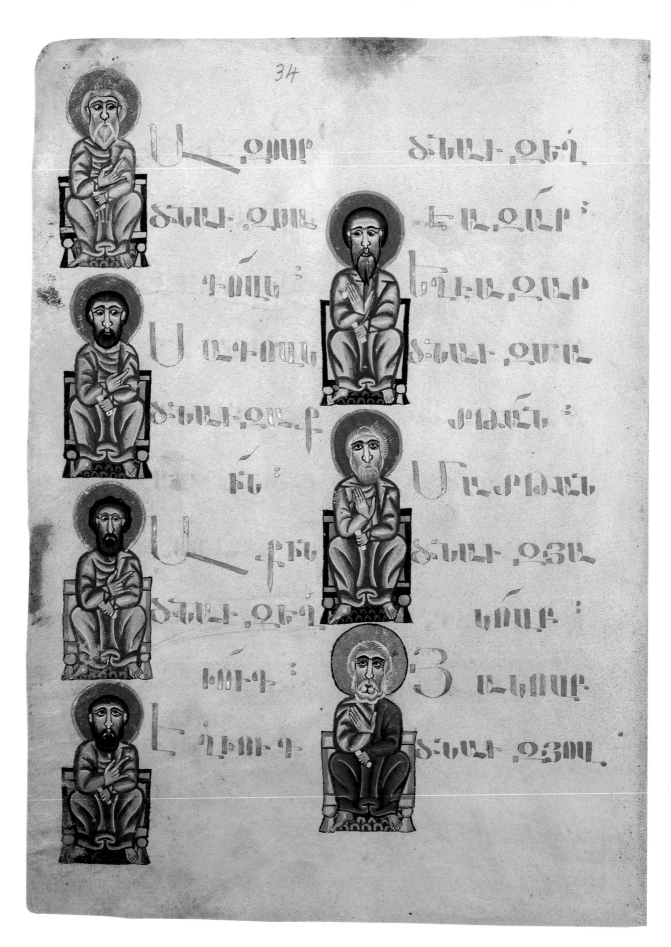

PLATE 11
Evangelist Painter, *The Genealogy of Christ.*
Gladzor Gospels, p. 34.

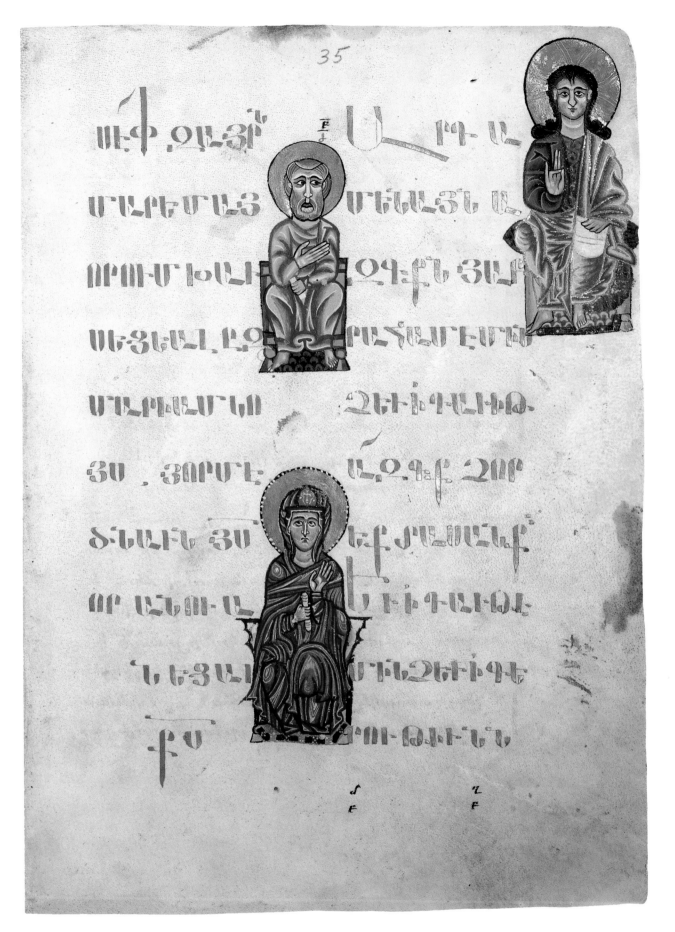

PLATE 12
Evangelist Painter and T'oros of Taron, *The Genealogy of Christ.*
Gladzor Gospels, p. 35.

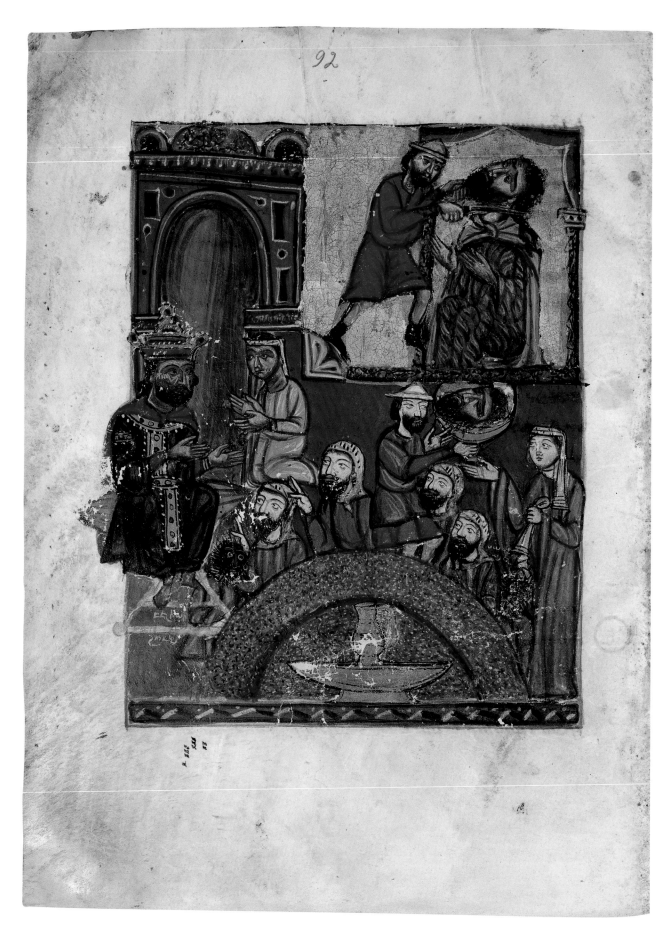

PLATE 13
Painter of the Green Ground and T'oros of Taron, *The Beheading of John the Baptist*.
Gladzor Gospels, p. 92.

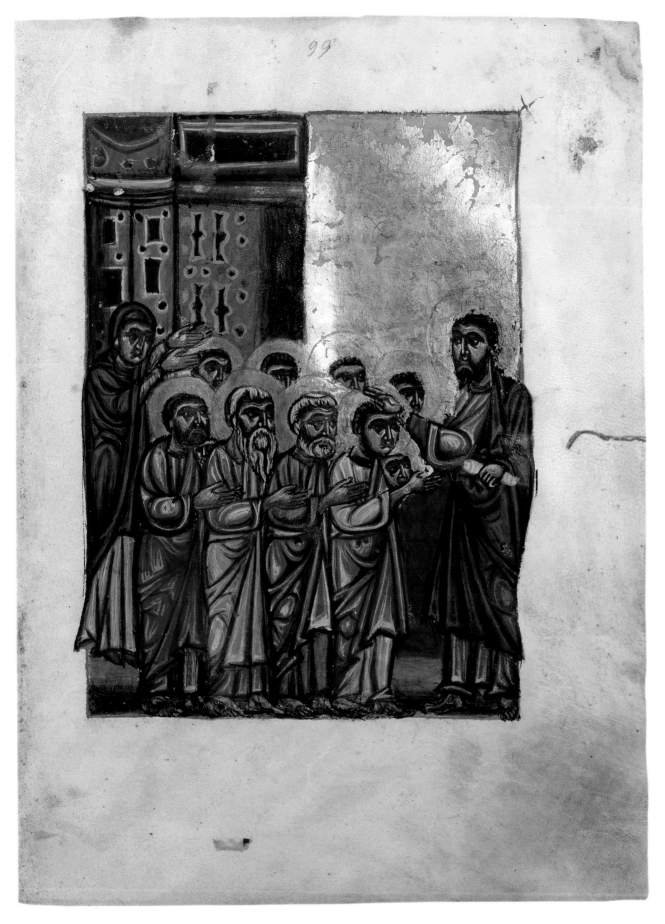

PLATE 14
Painter of the Green Ground, *The Petition of the Canaanite*.
Gladzor Gospels, p. 99.

PLATE 15
Painter of the Green Ground, *Saint Peter.*
Gladzor Gospels, p. 103.

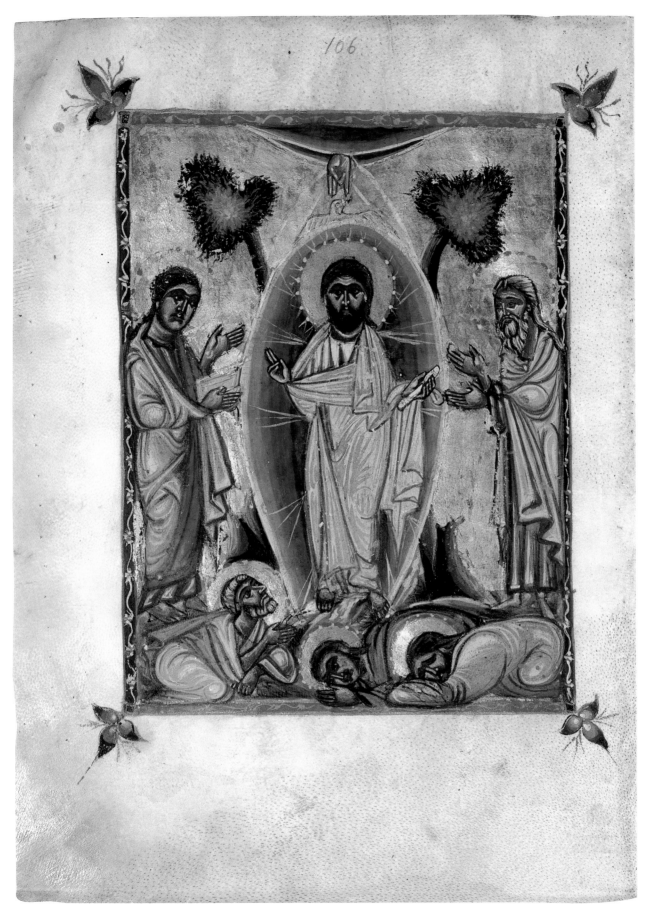

106.

PLATE 16
Painter of the Green Ground, *The Transfiguration*.
Gladzor Gospels, p. 106.

PLATE 17
Canon Table Painter, text page.
Gladzor Gospels, p. 111.

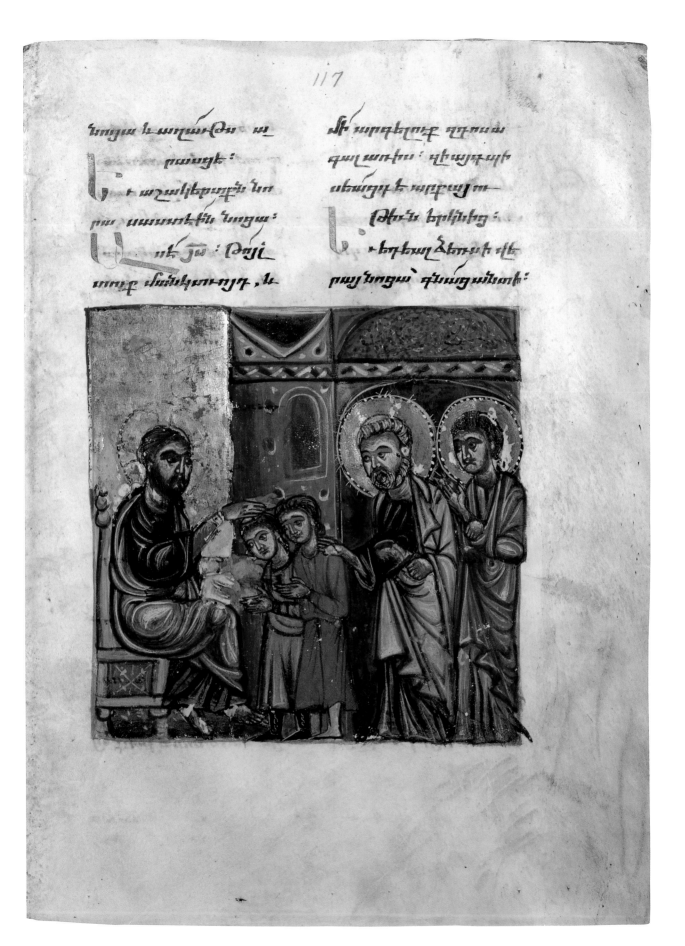

PLATE 18
Painter of the Green Ground, *The Blessing of the Children.*
Gladzor Gospels, p. 117.

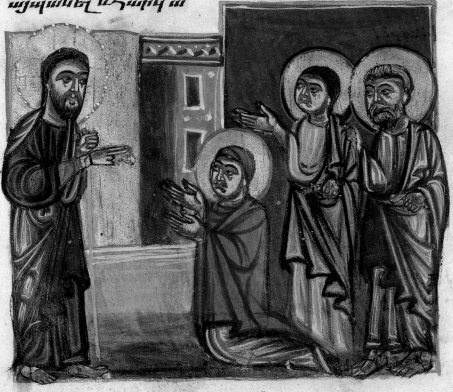

PLATE 19
Painter of the Green Ground, *Christ with the Mother of James and John.*
Gladzor Gospels, p. 122.

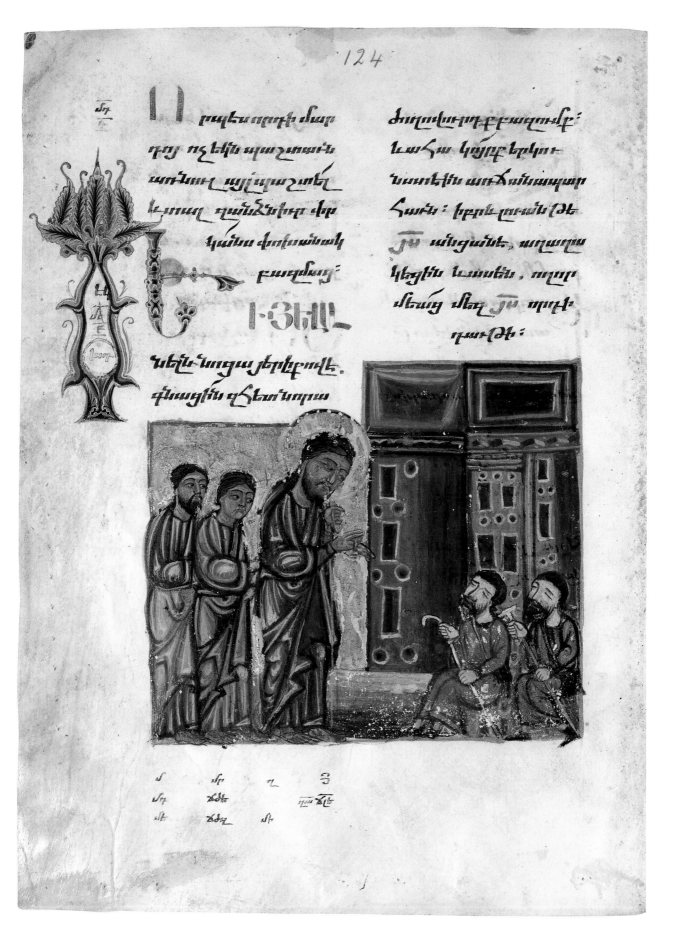

PLATE 20

Painter of the Olive Ground and T'oros of Taron, *The Healing of the Blind Men at Jericho.*

Gladzor Gospels, p. 124.

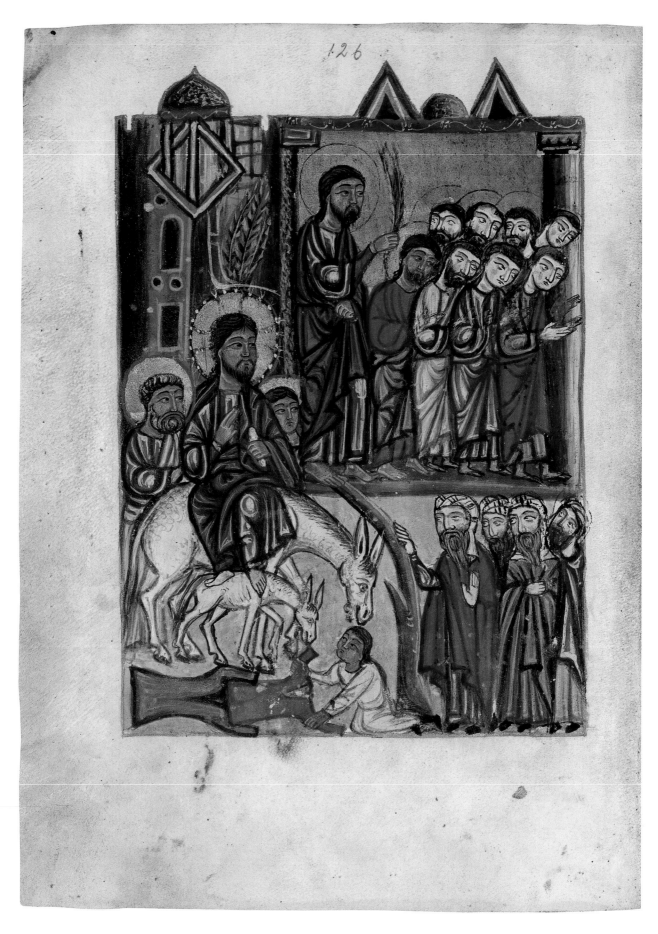

PLATE 21
Painter of the Olive Ground and T'oros of Taron, *The Entry into Jerusalem.*
Gladzor Gospels, p. 126.

156

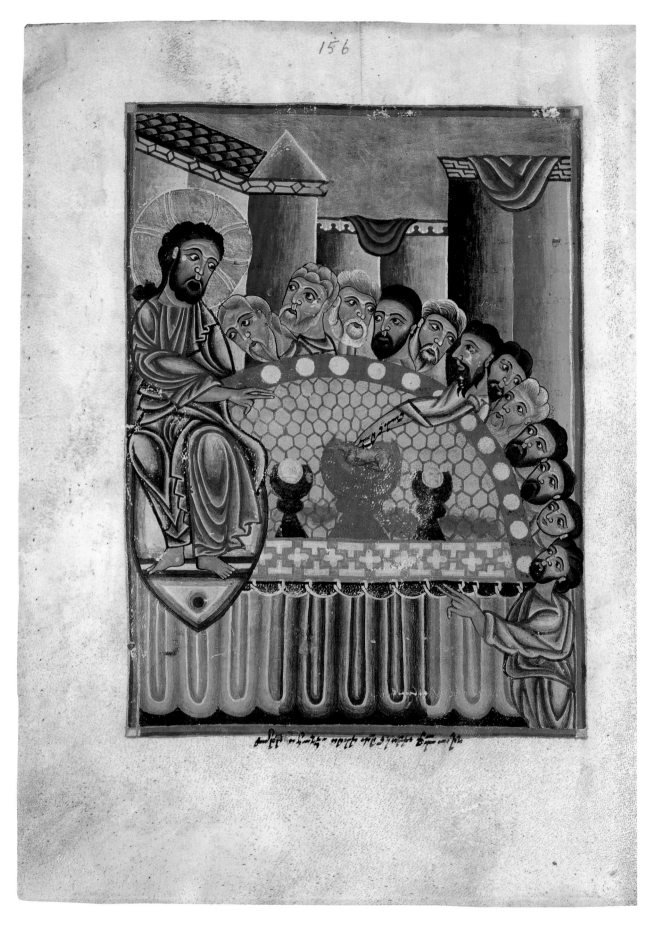

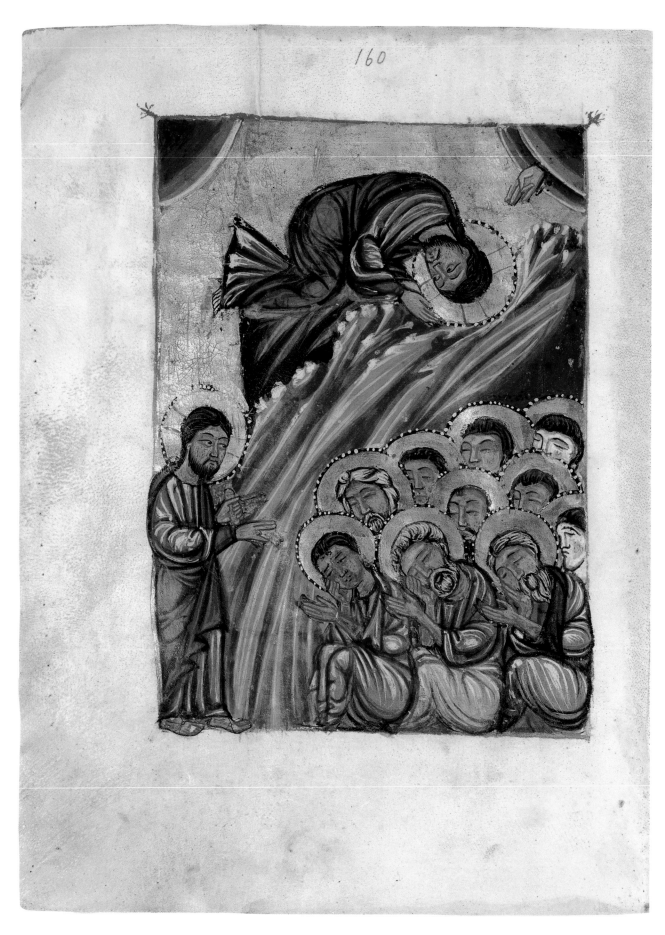

PLATE 23
Painter of the Olive Ground and T'oros of Taron, *The Agony in the Garden*.
Gladzor Gospels, p. 160.

162

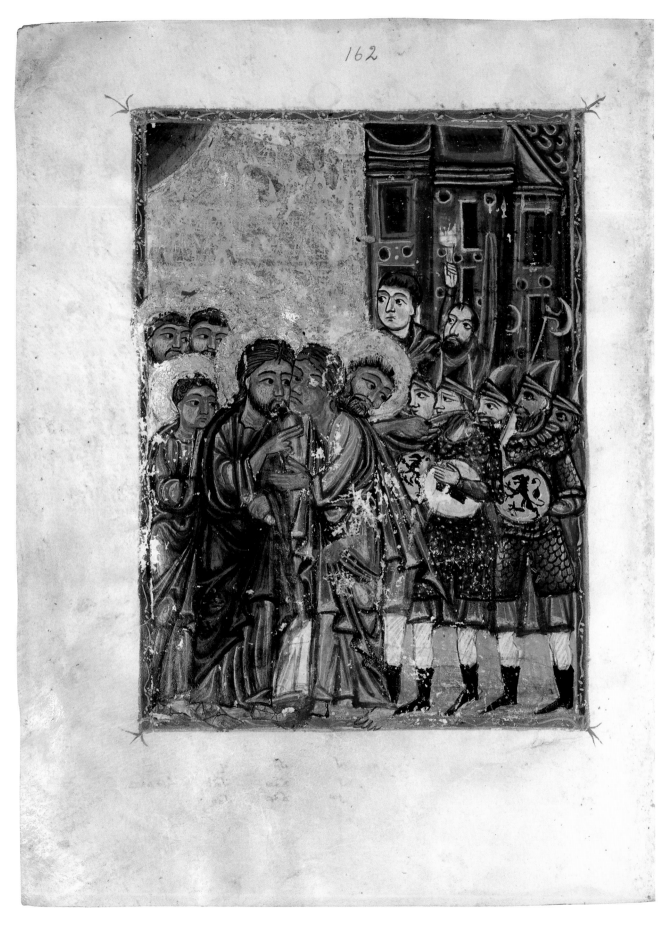

PLATE 24
Painter of the Olive Ground and T'oros of Taron, *The Betrayal of Christ.*
Gladzor Gospels, p. 162.

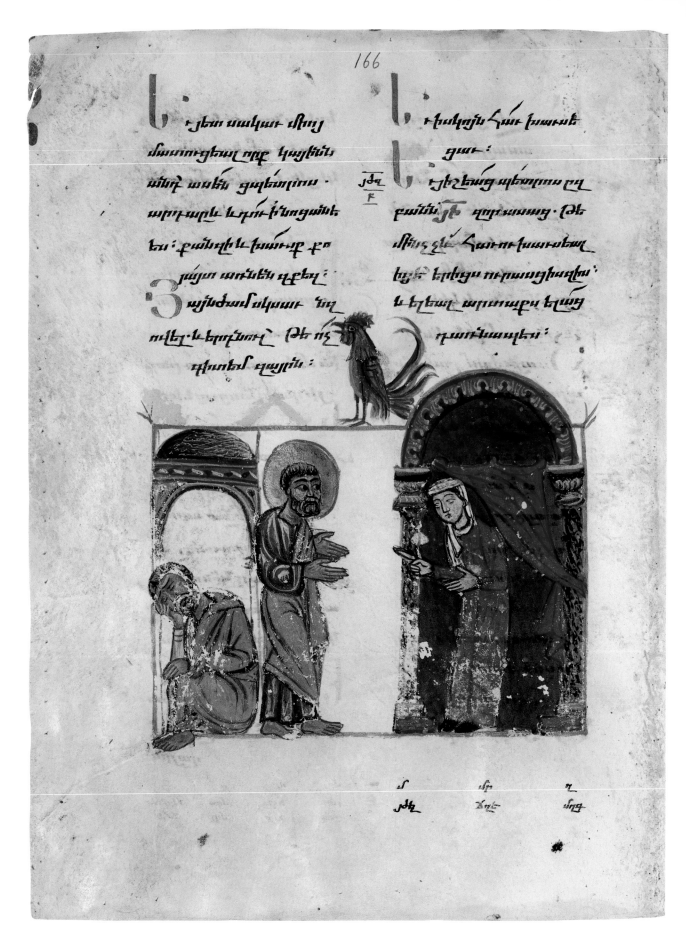

PLATE 25
Painter of the Olive Ground and T'oros of Taron, *The Denial of Saint Peter.*
Gladzor Gospels, p. 166.

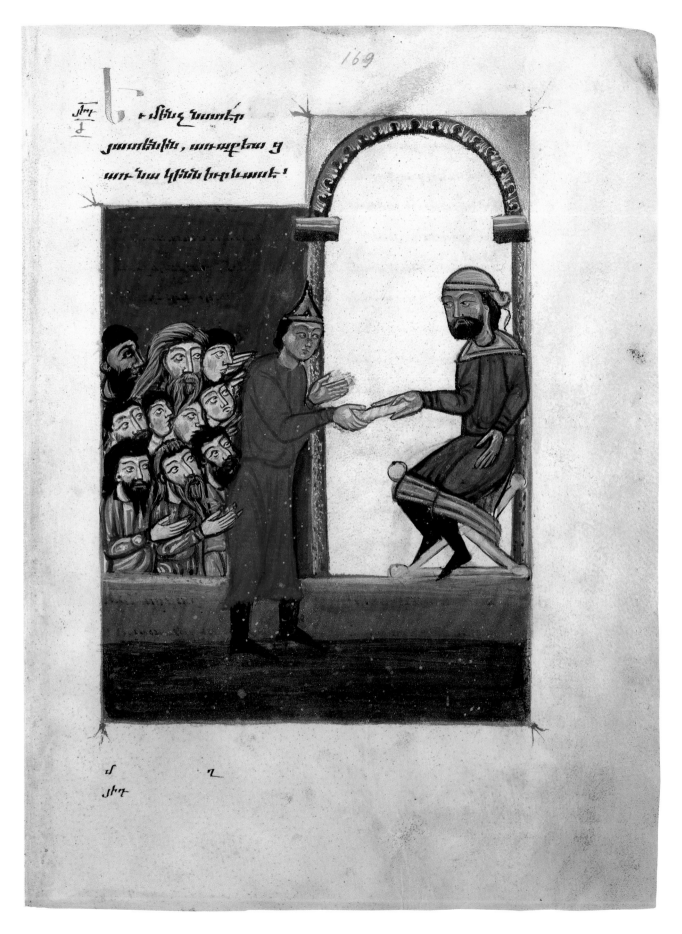

169

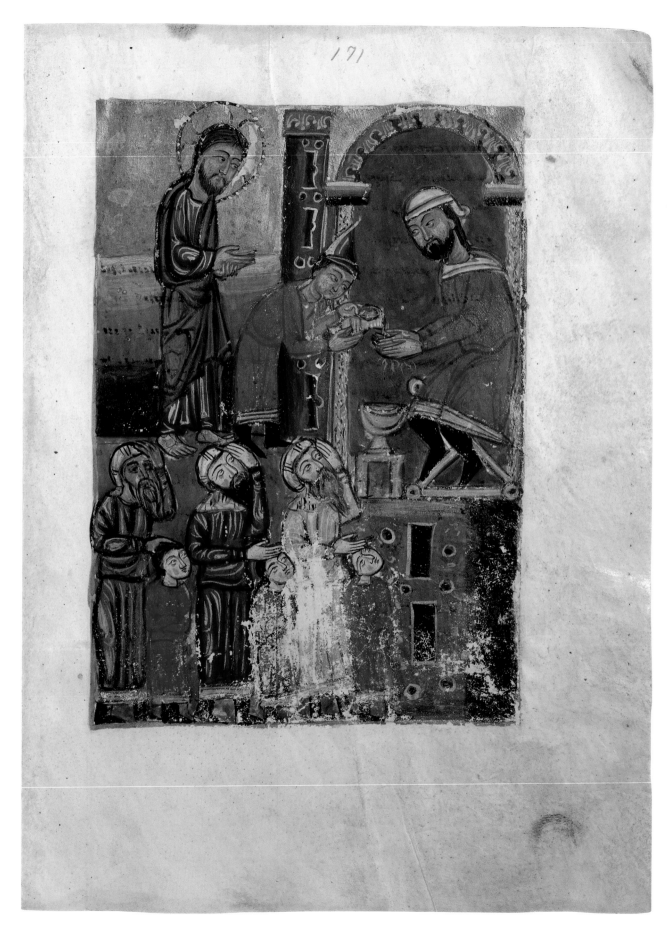

171

PLATE 27
Painter of the Olive Ground and T'oros of Taron, *Pilate Washing His Hands.*
Gladzor Gospels, p. 171.

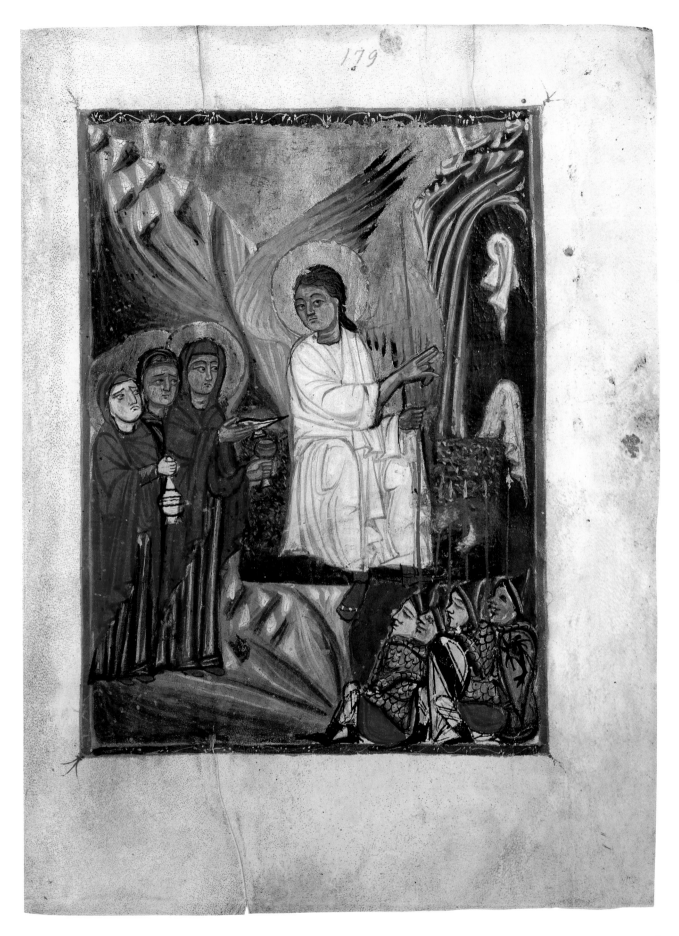

PLATE 28
Painter of the Olive Ground and T'oros of Taron, *The Women at the Tomb.*
Gladzor Gospels, p. 179.

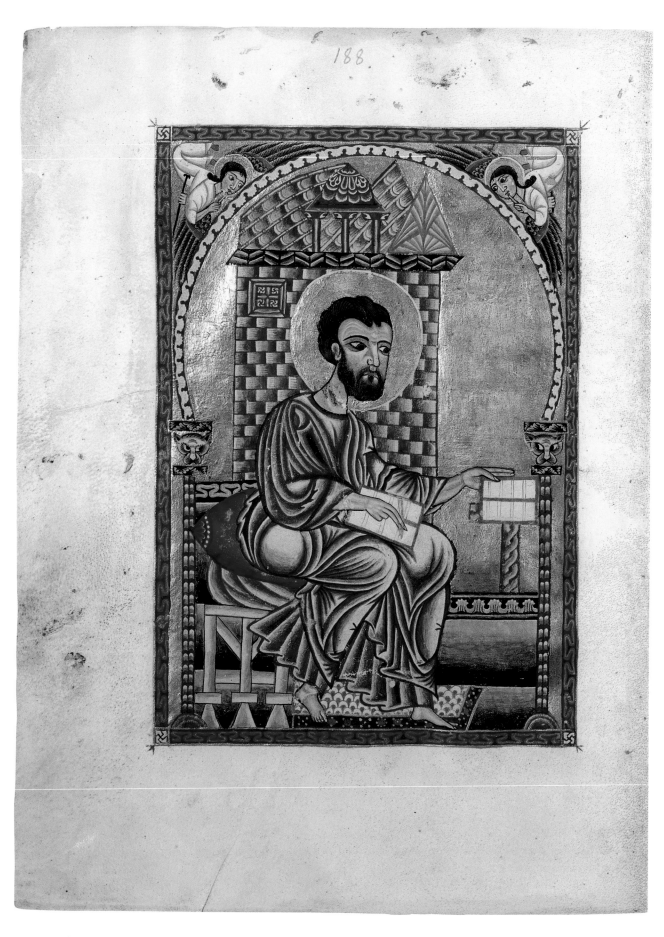

PLATE 29
Evangelist Painter, *Saint Mark.*
Gladzor Gospels, p. 188.

199

PLATE 30
Evangelist Painter, incipit page.
Gladzor Gospels, p. 189.

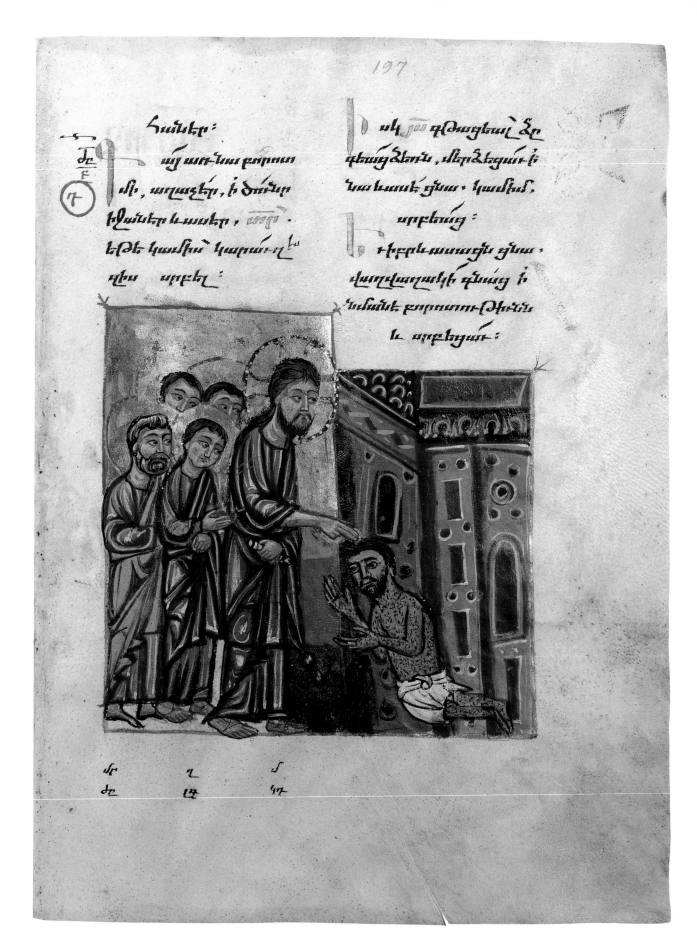

PLATE 31
Painter of the Olive Ground, *The Healing of the Leper.*
Gladzor Gospels, p. 197.

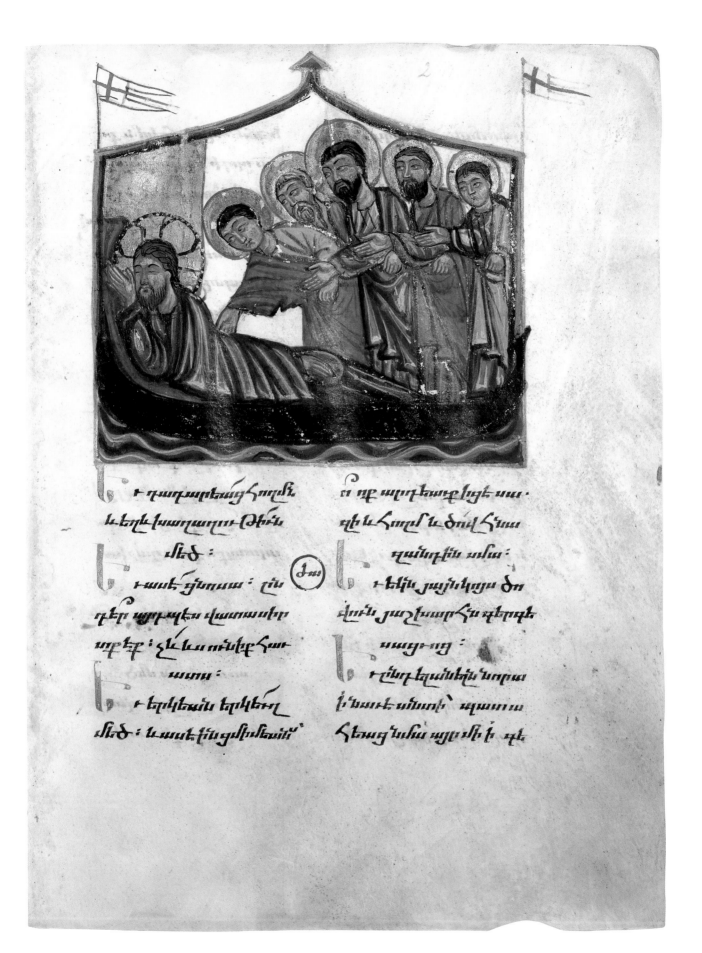

+ դարձաբեանց հոգև̅ ի
և ել̅ խառնարու Թիւս̅
մեծ :

+ աստ շիաստա : ընդ
զելս աշրաղեա վասասատա
աղ̅եբ : զե̅ տա ում̅եկ̅ հա̅
աստ :

+ եղևեանն երկինն
մեծ : աստ ընգստնեանն̅

ի̅ որ արդ̅արէ ինչ տա̅
զե̅ և հոմ̅ և ծնէ̅ հե̅ա
զամնրն աստ :

+ եղն յայնկիյս ծո̅
իմն յացխարս̅ հա̅ զերեն
աստիկ :

+ ե̅ե զգամնին նորա
ի̅ աստ ամստ̅ ապատ
հեաց նեւս աղ մեծ ի̅ զե

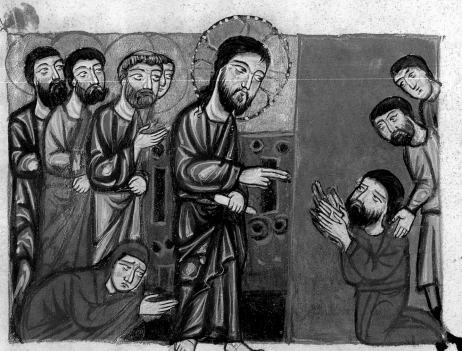

 զնա ի տանձնատացն։
. մնողես զառաջատրանին
պատմեաց ՟ջ յամինդեխտրդ
զաղտու Թեանն որեէ ենեան
նե։ դարձեաւ յաներեան
ն ասե. ով մերձեցաւ ի
Հանդերձս իմ։
. ասեն ընաս աշակե
րտքն։ տեսանեես զի ամ
բոխք նեղեե զքեզ։ ե

ասես Թե ով մերձեցաւ
ի Հանդերձս իմ։
. շուրջ Հայեեր աս
տանել Թեոն զազետարակ։
. կինն զազ Հաւետաա
եւպատատեան . վասնորոյ
գարշին ապատր։ զնա դե
զնաստեր զինեչ երեեան
։ եկեն աներեն առաջի նորա
եասաց զաունեեճայն երան

PLATE 33
T'oros of Taron, *The Healing of the Woman with a Hemorrhage.*
Gladzor Gospels, p. 216.

218

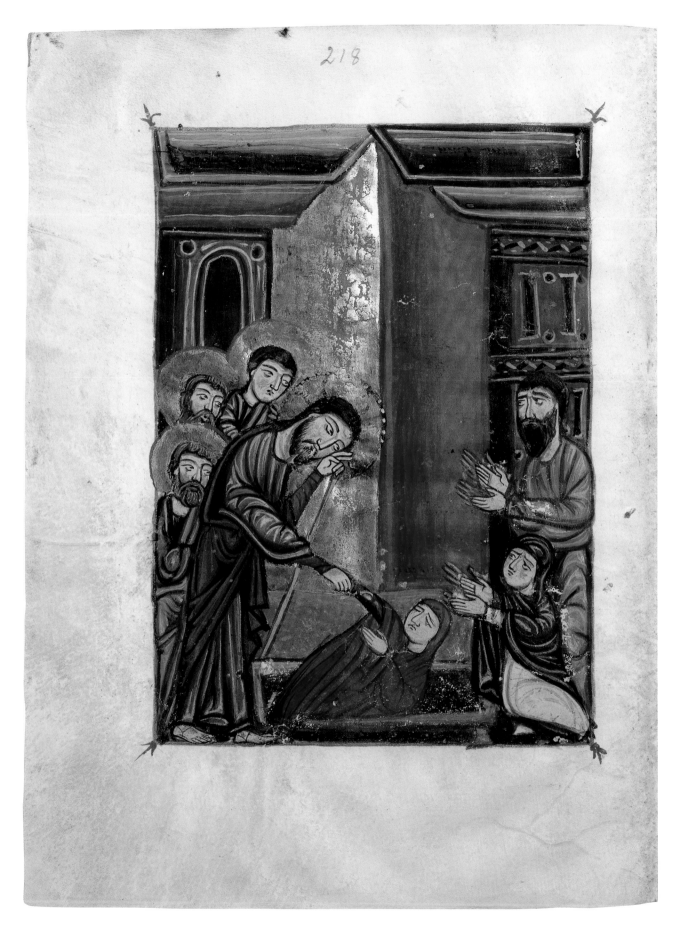

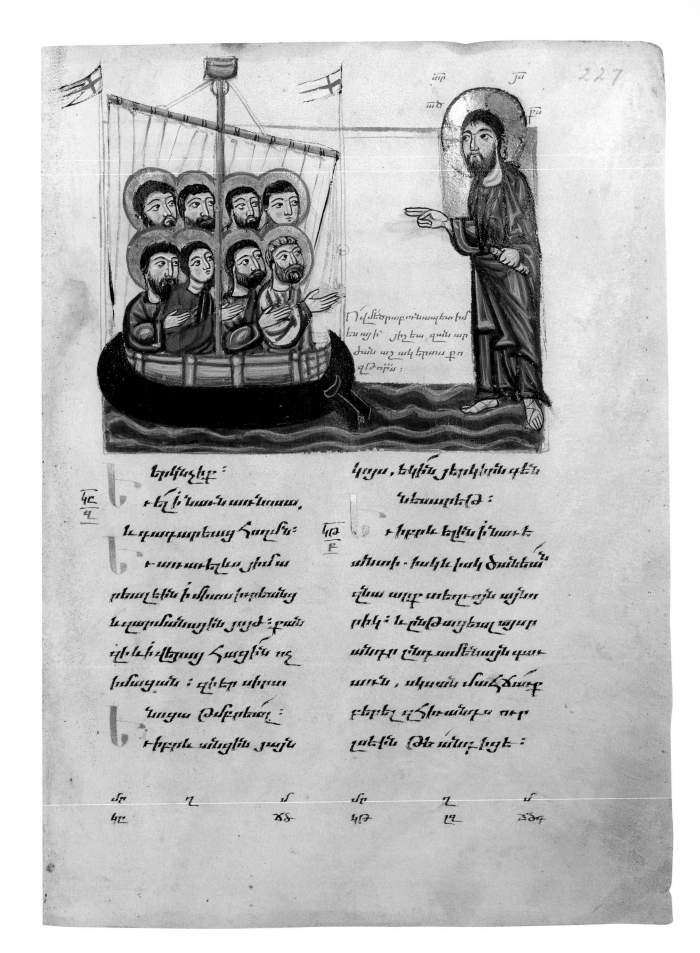

PLATE 35
T'oros of Taron, *The Second Storm at Sea.*
Gladzor Gospels, p. 227.

Ի ևու զխոսա · ևակ
զևսարդ ոչ ելնումայ·է ։

ան ի ըևալումիոյ ·
ևա ձեռն առալ զևորա
կոյս ել ։ և ևալ ելել ելա
զևստերձայ ի ևա ։

Ի ևոնա զգավումեա
կոյենն, և ևան աևամայդի
ուենն ։ և ևայ յայս ևո
ևա · և ևեռ ևել ի ելեայ ևո
ևա · և ևաեգումեր զևա
ևետայեանելե ևա։

այււ ևա ևատեր, ևևա
ևամեմ զևաղվավ ելե ևա
 շեիմե երեր գ ևավա
աև ևամ երե ևեա
ի ելեայ աև ևավ ևո ևա
ևեամ ևաևետավ ի ։ ևՉ
այււ ևաևետավ ևավավ
Չավ գավճեմայե ։

ևավկեայելեն ել
ււեի ելեավավ · ի ևելե
ևեմավեելեայ · այ ելի
այելեա ։ ևորճավ ի ել
ևավավելեայ, ելե ու
ելեր ււավայելեա ի ելի ել

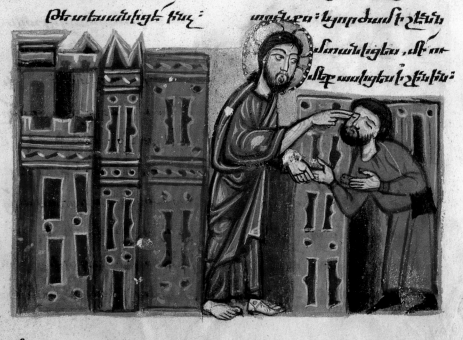

սր
Չա

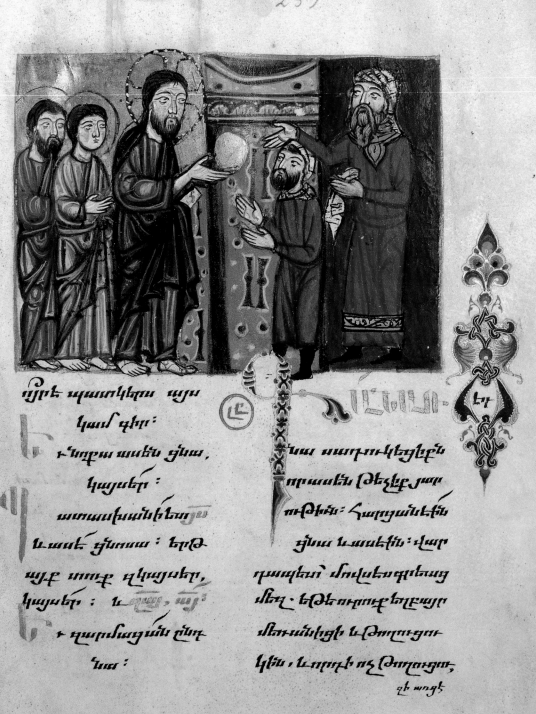

259

 մյրե պատոկեցաս այս
կամ զեր:
ե նորա ասեն չնա,
կայսեր:
ատատխանենեղ
և ասե չնա: երե
այբ սոպ զկայսեր,
կայսեր: և պարսագաս ընո
կա:

սա տարոսկեցեր
որասեն թեզեր չաս
պեին: Հայրանեն
չնա և ասեն: վար
պասեն մոխտգրաս
մեն, երեսաբութեպայ
մեսանիցե և թոռաչա
կես, և որեր ոչ թոռաչա
զե աող

PLATE 37
T'oros of Taron, *The Question of Tribute to Caesar*.
Gladzor Gospels, p. 259.

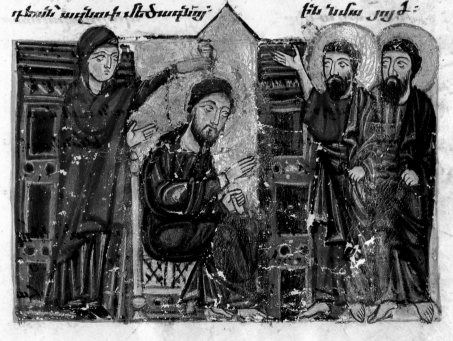

271

զե կերիցեզպատրաստե երրև մատանիցէ ի
ւատայե երկիա զաղաքն, պատանիեա
յաշականայց անան ցե Հետայսեր որ սա
ևատան զնատա։ Երթ վոր քեզ յատ ունիցե
մին զաղացն, ևւ երեզ զիտեարնպա

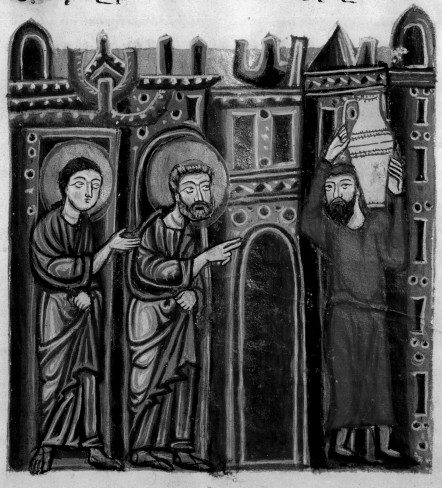

PLATE 39
T'oros of Taron, *The Preparation for Passover.*
Gladzor Gospels, p. 271.

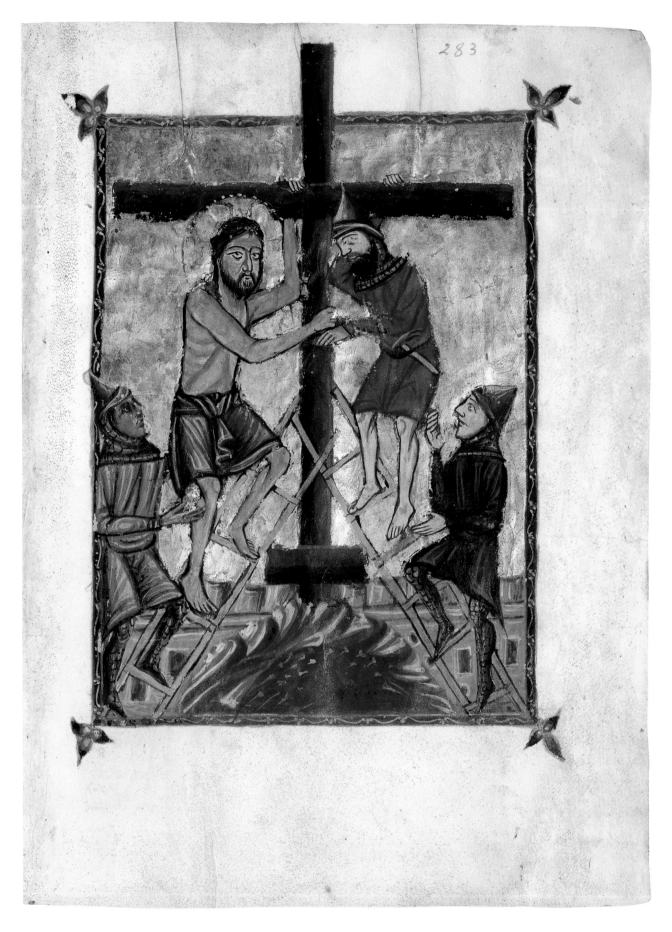

283

PLATE 40
T'oros of Taron and the Painter of the Olive Ground, *Christ Ascending the Cross.*
Gladzor Gospels, p. 283.

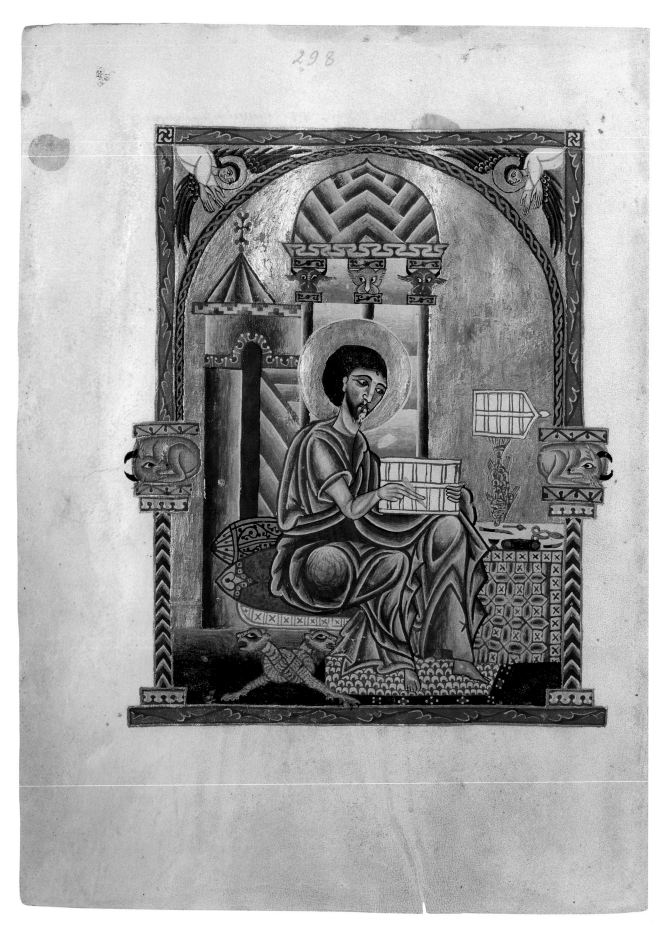

PLATE 41
Evangelist Painter, *Saint Luke*.
Gladzor Gospels, p. 298.

PLATE 42
Evangelist Painter, incipit page.
Gladzor Gospels, p. 299.

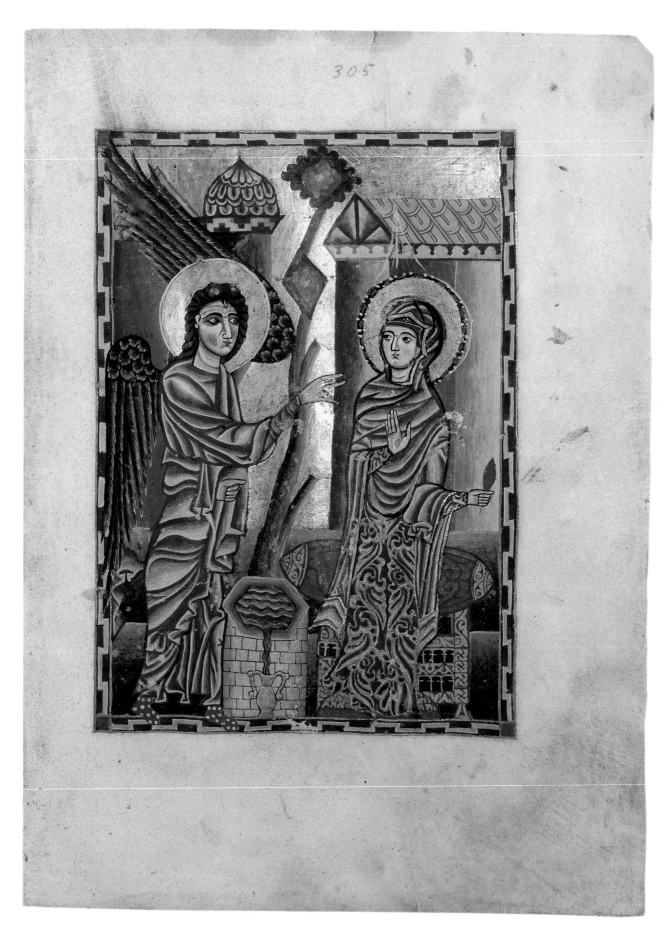

PLATE 43
Evangelist Painter and T'oros of Taron, *The Annunciation.*
Gladzor Gospels, p. 305.

312

PLATE 44
T'oros of Taron, *The Visitation.*
Gladzor Gospels, p. 312.

PLATE 45
T'oros of Taron, *Christ Reading in the Synagogue.*
Gladzor Gospels, p. 327.

351

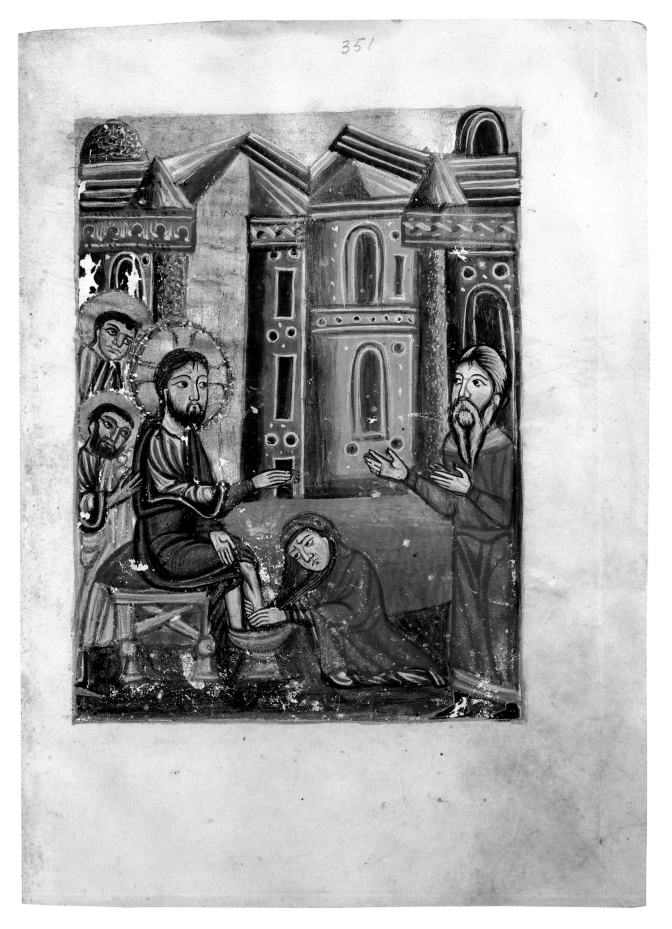

PLATE 46
T'oros of Taron and the Painter of the Olive Ground, *The Anointing of Christ at Simon's House.*
Gladzor Gospels, p. 351.

PLATE 47
T'oros of Taron, *The Parable of the Cunning Steward.*
Gladzor Gospels, p. 403.

438

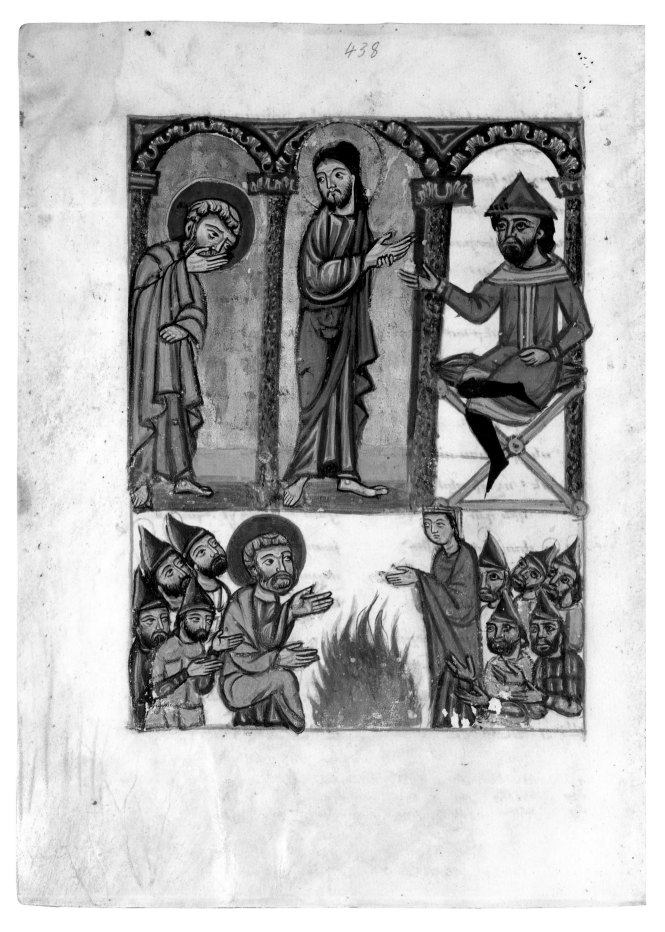

PLATE 48
T'oros of Taron and the Painter of the Olive Ground, *The Denial of Saint Peter.*
Gladzor Gospels, p. 438.

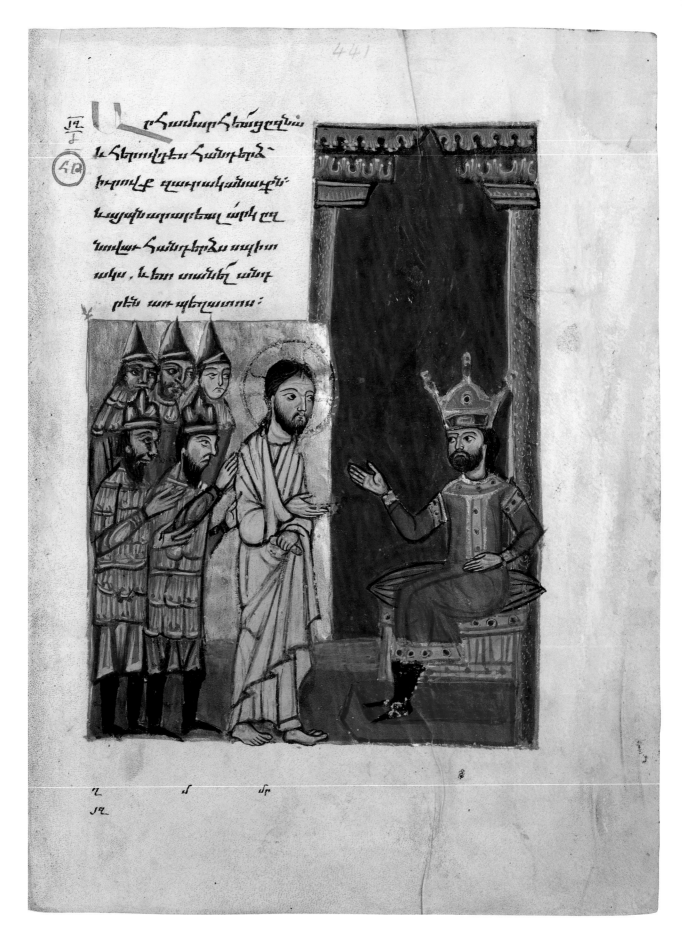

PLATE 49

T'oros of Taron and the Painter of the Olive Ground, *Christ Before Herod.*

Gladzor Gospels, p. 441.

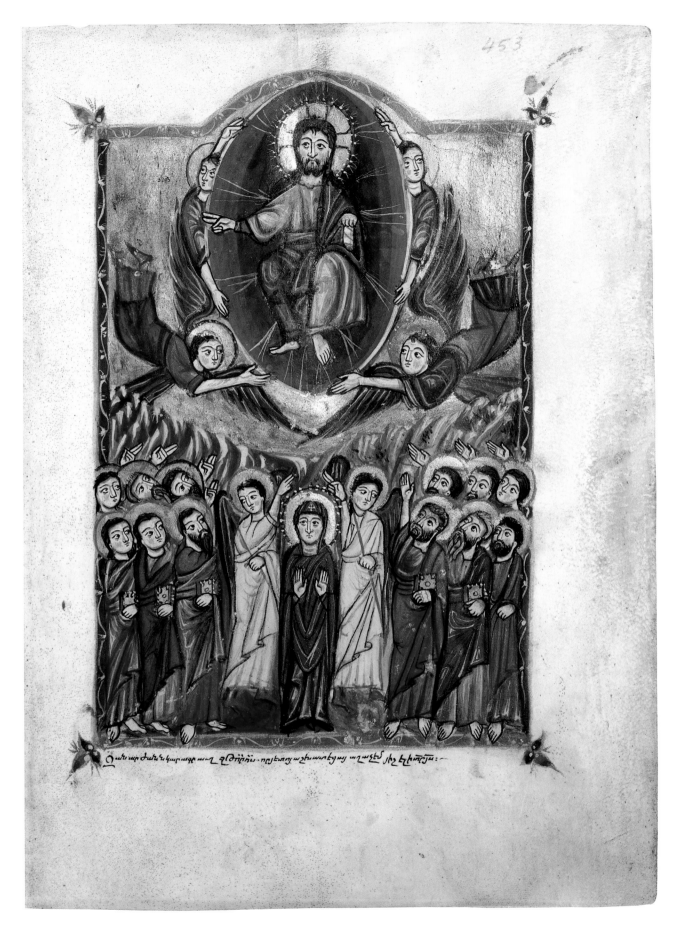

Հաս առ ժառանգեկ ապա աւ զԹովմին որյ տայ աշնատեւցայ աղաչել լեզ եկրյուն։

PLATE 50
T'oros of Taron, *The Ascension.*
Gladzor Gospels, p. 453.

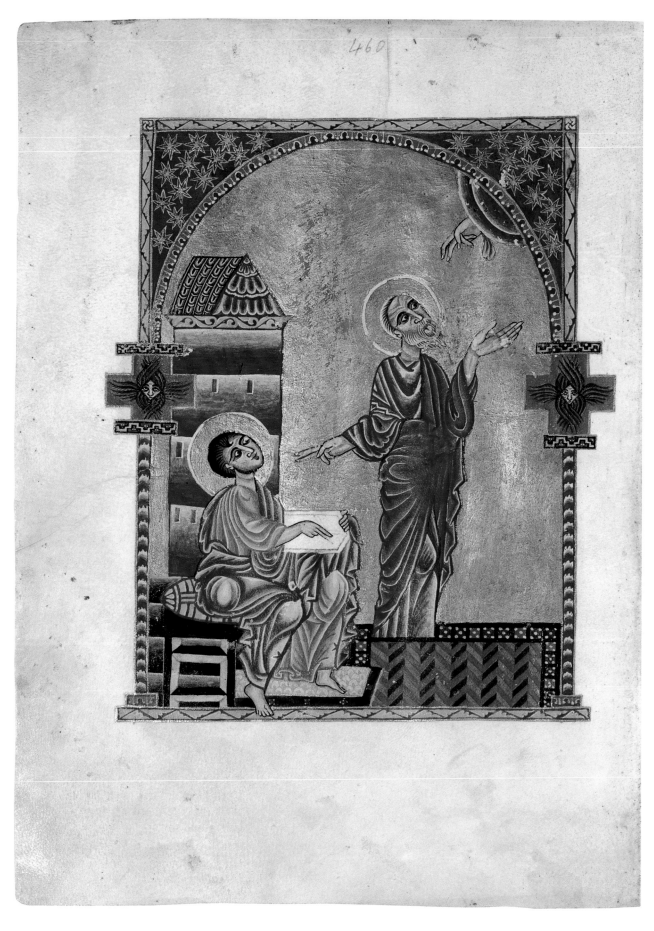

PLATE 51
Evangelist Painter, *Saint John.*
Gladzor Gospels, p. 460.

PLATE 52
Evangelist Painter, incipit page.
Gladzor Gospels, p. 461.

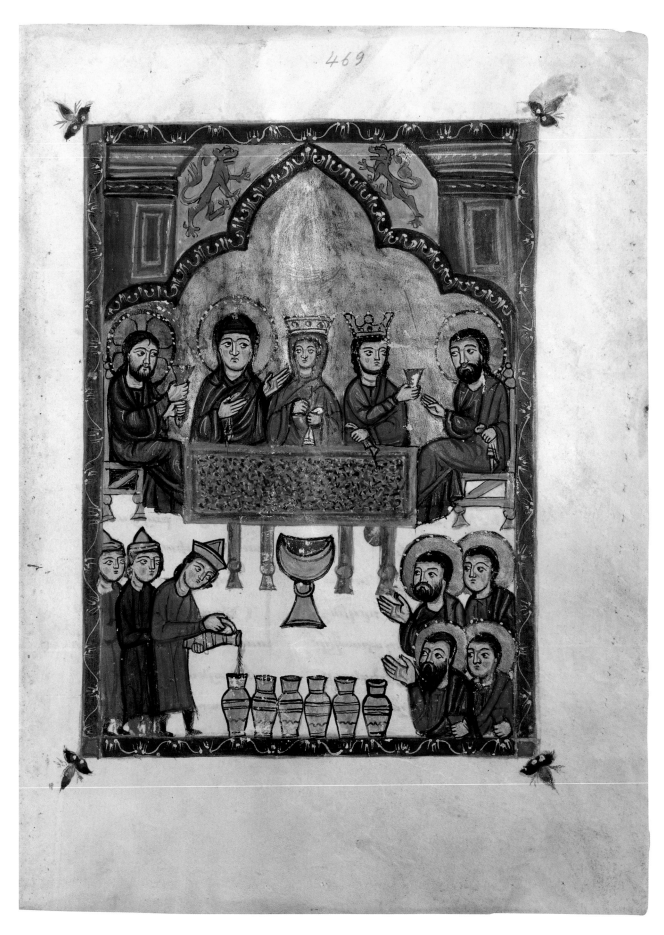

PLATE 53
T'oros of Taron, *The Marriage at Cana.*
Gladzor Gospels, p. 469.

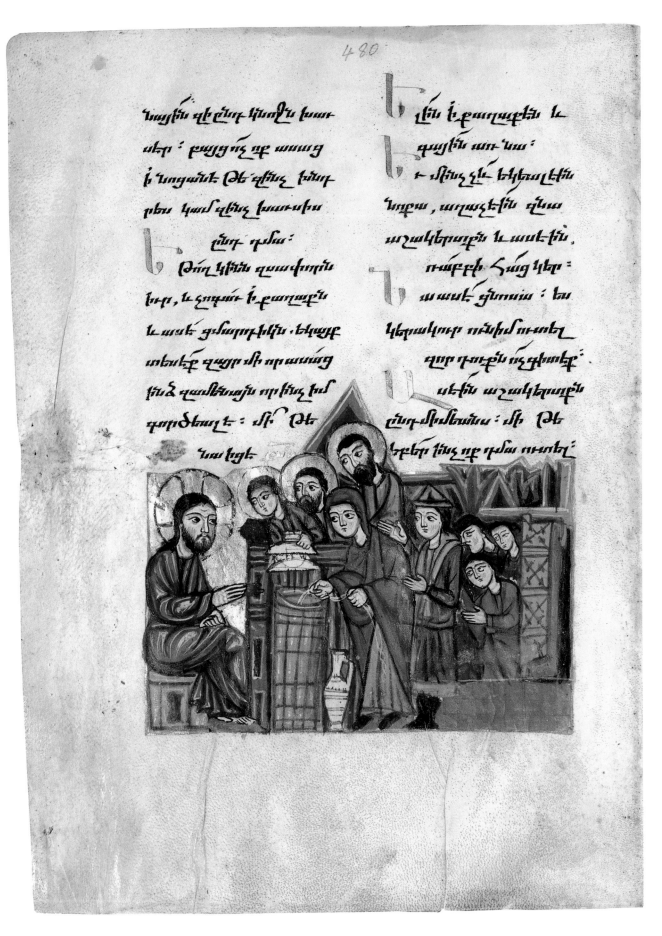

PLATE 54
T'oros of Taron, *Christ and the Samaritan Woman.*
Gladzor Gospels, p. 480.

509

ասէին։ ոչ ասէր այր
 կատերին և տուրբաայր։
էղէն ասէին, նա է։
այլ ջն ասէ նմ ոչ ։ այլ
նմանէ նմա ։
և էղէն ասէր, Ժենենէ։
նմ ցնա ։ իսկ
զի այրդ բացաւ աչ քո

ա և ո պատասասնախ։
այլ ջն ոչ գիաամ յինչ ասեմ.
կամ արբար և ծերետա ց
զաչս էմ, և ասէ ցնա
երթ ի սերխմաս խրսն
ղուգայ լոսացայ և ստե
ասամէն ։

PLATE 55
Evangelist Painter and T'oros of Taron, *The Healing of the Man Born Blind.*
Gladzor Gospels, p. 509.

PLATE 56
Evangelist Painter, text page.
Gladzor Gospels, p. 514.

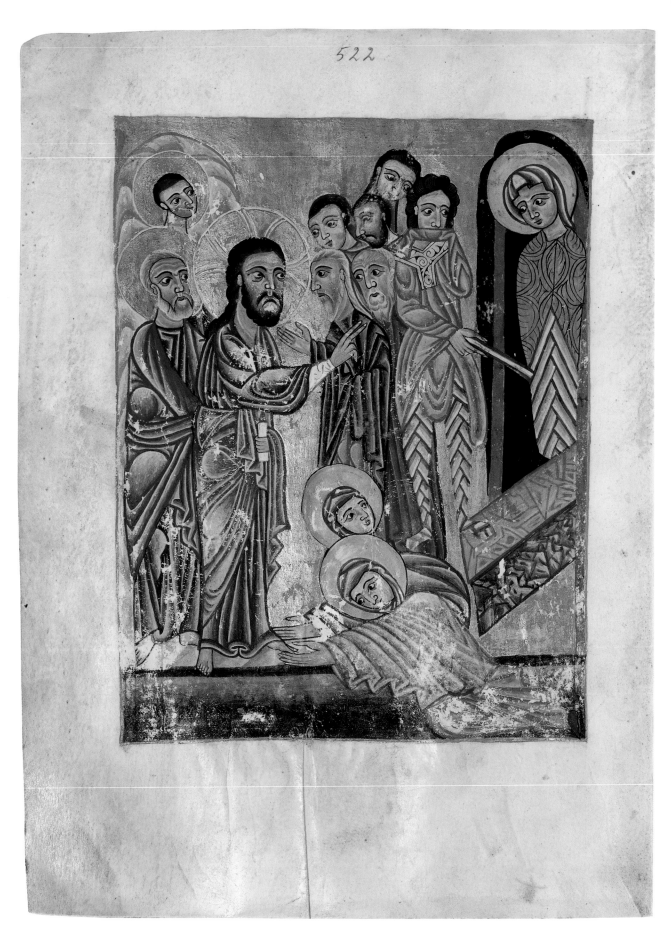

PLATE 57
Evangelist Painter, *The Raising of Lazarus.*
Gladzor Gospels, p. 522.

532

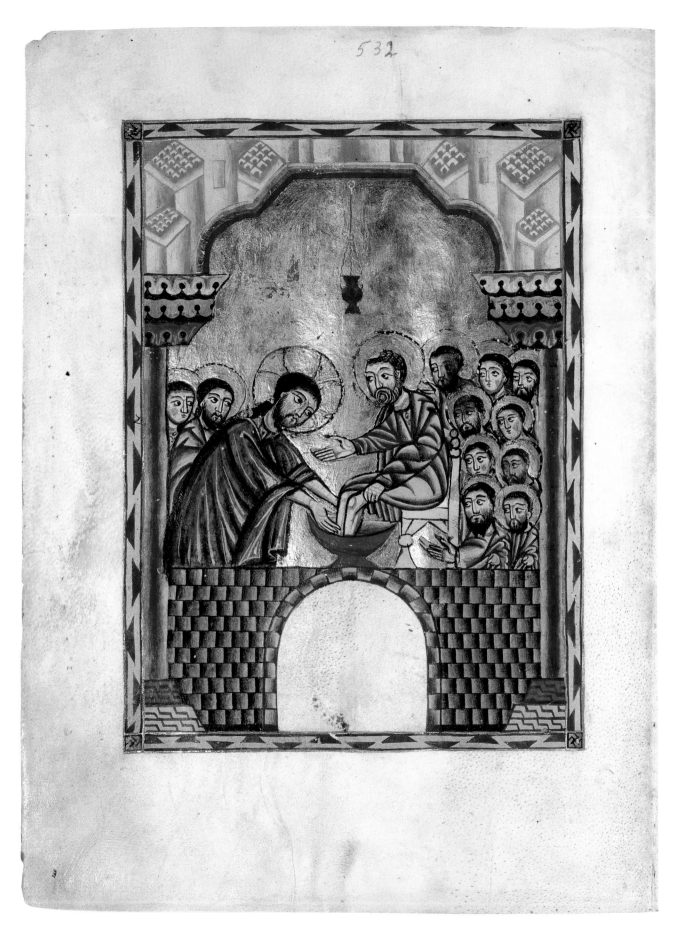

PLATE 58
Evangelist Painter and T'oros of Taron, *Christ Washing the Apostles' Feet.*
Gladzor Gospels, p. 532.

561

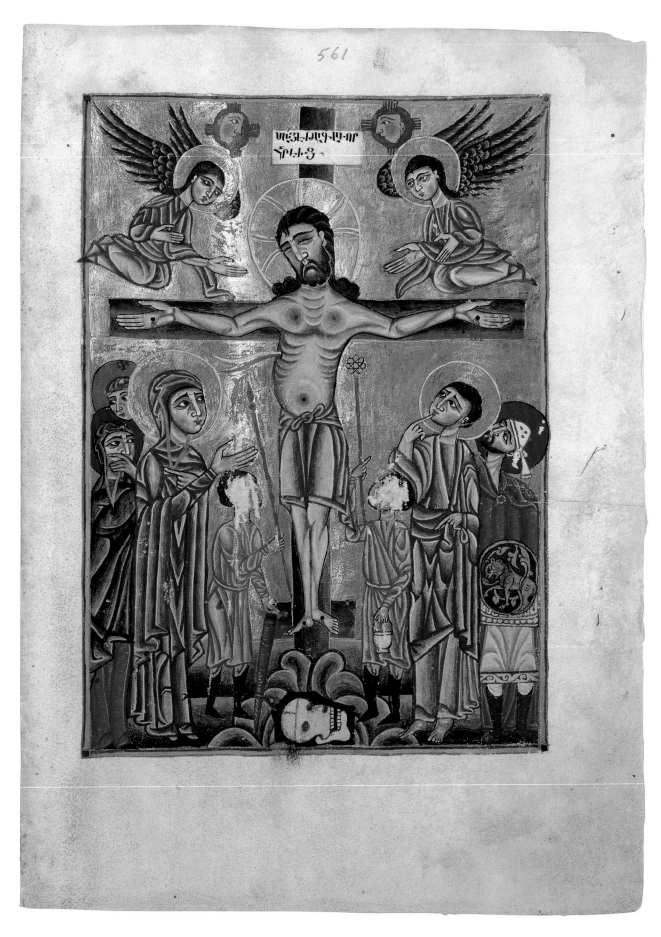

PLATE 59
Evangelist Painter, *The Crucifixion.*
Gladzor Gospels, p. 561.

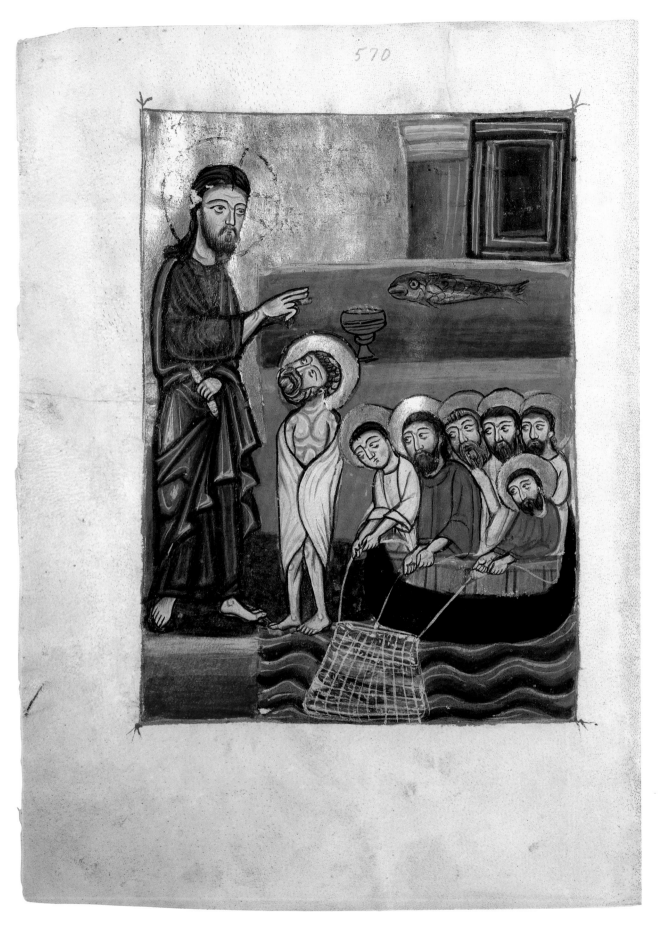

570

CANON TABLES
A set of tables developed by Eusebius of Caesarea in the fourth century to display the concordance of the four Gospels. Each column of numbers in the table indicates passages from a single Gospel. Read horizontally, each row of numbers identifies where the same event is described in other Gospels. These tables are often preceded by the letter of Eusebius to Carpianus, in which Eusebius explains his system.

DUOPHYSITE
One who holds that the two natures in Christ are distinct and unmixed.

EXEGESIS
The interpretation of Scripture.

HOMILIARY
A book of sermons.

INCIPIT
The opening words of a text, from the Latin verb *incipere* (to begin).

MATINS
The predawn prayer service celebrated daily by monks, nuns, and clerics in the Middle Ages.

MENOLOGION (pl, menologia)
A book of saints' lives.

MONOPHYSITE
One who holds that Christ has only one nature. Erroneously applied to the Armenian Church.

NAKHARAR
A member of the Armenian nobility, with hereditary rights to certain lands and offices.

NESTORIANISM
A movement named for Nestorius (fourth century). Nestorian insistence on the full humanity of Christ was considered contrary to orthodox doctrine because it seemed to divide him into two persons, one human and the other divine.

PERICOPE
A passage excerpted from a text, especially an excerpt from the Bible read in the Christian liturgy.

QUADRIVIUM
The sciences of geometry, arithmetic, music, and astronomy in the medieval European university curriculum.

TRIVIUM
The sciences of grammar, rhetoric, and logic in the medieval European university curriculum.

UNIATE MOVEMENT
A movement to align the doctrines of one of the Eastern churches with those of the Roman Catholic Church.

VARDAPET
An Armenian religious teacher of the highest qualifications.

Der Nersessian, S., *Armenian Art* (London and Paris, 1978).

———, *Miniature Painting in the Armenian Kingdom of Cilicia from the Twelfth to the Fourteenth Century*, 2 vols. (Washington, D.C., 1993).

Hovanissian, R.G., ed., *The Armenian People from Ancient to Modern Times*, 2 vols. (New York, 1997).

Mathews, T.F., and A.K. Sanjian, *Armenian Gospel Iconography: The Tradition of the Glajor Gospel* (Washington, D.C., 1991).

Mathews, T.F., and R.S. Wieck, eds., *Treasures in Heaven: Armenian Illuminated Manuscripts* (New York, 1994).

Taylor, A., *Book Arts of Isfahan: Diversity and Identity in Seventeenth-Century Persia* (Malibu, 1995).

Thomson, R.W., *The Teaching of Saint Gregory: An Early Armenian Catechism* (Cambridge, Mass., 1970).

———, "The Historical Compilation of Vardan Arawelc'i," *Dumbarton Oaks Papers* 43 (1989): 125–226.

Soucek, P.P., "Armenian and Islamic Manuscript Painting: A Visual Dialogue," in T.F. Mathews and R.S. Wieck, eds., *Treasures in Heaven: Armenian Art, Religion, and Society* (New York, 1998), pp. 115–31.

NOTE: Page numbers in *italics* indicate illustrations.

influence in Armenia, 23, 50
 resistance to, 29, 46, 49
Roman Catholic Crusaders, alliances with,
21, 23

S

Sacred Scripture, Armenian translations of,
13, 31
Sadayel (demon), 43, 66
Salome (daughter of Herod), 16, 41, 42, 66
Salome (sister of the Virgin Mary), 39, 41
Samaritan woman, 45, 107
Sanjian, Avedis K., 51
Sargis (artist), 18, 27
 The Raising of Lazarus, 18
The Second Storm at Sea, 35–36, 88
 inscription in, 16, 17
Seljuks, 21, 22
Shun, Beliar (demon), 43, 66
Simon the Pharisee, 43, 99
Siunik' (province), 7, 25, 26
 monasteries in, 27
 painters active in, 18
Smbat, Constable, 24
Sultaniye, 7, 26, 50
Syriac Christians, 21
Syrian theology
 Christ the Physician in, 32, 33
 Transfiguration in, 36

T

T'amar, Queen of the Georgians, 22, 23
Tamurlane (Khan of the Mongols), 50
Taron (province), 25. *See also* T'oros of Taron
taxes, exemption from, 24, 40
Teaching of Saint Gregory the Illuminator, 32, 38
Timaeus (Plato), 28
T'oros of Taron (artist), 16, 17, 19
 faces painted by, 17, 19
 illustrations by, *86–92, 97–103, 106–107, 113*
 with Evangelist Painter, *65, 96, 108, 111*
 with Painter of the Green Ground, *66*
 with Painter of the Olive Ground,
 73–74, 76–81, 93, 99, 101–102
 interpretations of life of Christ, 35, 36, 40
The Transfiguration

in Gladzor Gospels, 36–37, *69*
 by Momik, *18*
trial of Christ, illustrations of, 45–46, *79, 80*
Trisagion Hymn, 38, 40
Tsortsorets'i, John. *See* John of Yerzinka

U

Uniate movement, 50, 114
universities, Western medieval, 28

V

Vakhakh, Princess, 50
vardapet (honorific title), 25, 114
Vayotz Dzor, 10, 18, 26
Vehap'ar Gospels, 17, 27, 49
 illustrations in, *16–17, 44*
 as model for Gladzor Gospels, 17
The Visitation, 42, *97*
von Grunebaum, Gustav, 51
Vorotn (monastery), 25, 26
Vosper, Robert, 51

W

wedding, Armenian, 47
William of Rubruck, 15, 24
women, in Gladzor Gospels, 16, 34, 41–45
The Women at the Tomb, 43, *81*

Y

Yeghegis (monastery), 18, *26*, 27
Yesayi of Nich, 17, 25, 28
 commentary on Isaiah, 47
 inscription to, 16, 35, *88*
 portrait of, 28–29, *29*
 students of, 49–50
 work at Gladzor, 29
Yovhan (John) of K'rnay, 49, 50
Yovhan (John) of Vorotn, 50
Yovhannes of Yerzinka. *See* John of Yerzinka

Z

Zachariah the Priest, 42, *97*
Zak'arian, Ivane, 22–23
Zak'arian, Zak'are, 22–23

OVERLEAF
Detail of Plate 42.